THE ART OF
Minnie Mouse

THE ART OF
Minnie Mouse

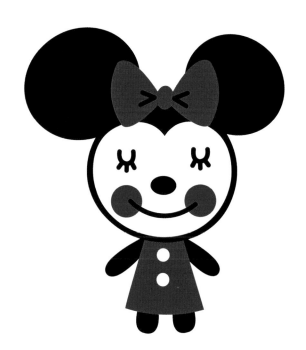

EDITIONS

Los Angeles • New York

Editorial Director: Wendy Lefkon

Senior Editor: Jennifer Eastwood

Designer: Alfred Giuliani

Art Traffic Coordinator: Danielle Digrado

"Her Animated Filmography" and "Her Milestones" compiled by Jennifer Eastwood.
A special thank you to Kevin Kern and Dave Smith for their input.

Quotes in "Her Gallery" compiled by Beckie and Jennifer Eastwood.

Archival photographs, book covers, film posters, final frames, magazine covers and interior page, and story scripts on the following pages courtesy the Walt Disney Archives Photo Library: 12–15, 18–27, and 29–36.

Archival photograph of Ub Iwerks and Win Smith on page 25 and the comic strips, book covers, magazine cover, and original $10 Disney Dollar image and advertisement on the following pages courtesy the Walt Disney Archives: 24, 26, 28–30, and 37.

Artwork on the following pages courtesy cast members of Disney Consumer Products and Interactive Media: 3 and 44–159.

Character lineup on page 41 reproduced from *An Animator's Gallery: Eric Goldberg Draws the Disney Characters* (Disney Editions, 2015) and courtesy the Walt Disney Animation Research Library.

Disney California Adventure $10 Disney Dollar image on page 37 courtesy Deborah Eastwood.

Disney Park photographs on the following pages courtesy Resource Café: 33 (first photographed by Cynthia Perez and produced by Justin Seeley; second photographed by Matt Stroshane and art directed by Bil Shannon; third photographed by Jimmy DeFlippo; fourth photographed by Chris Sista; and fifth photographed by Stephanie Rausser and produced by Nicholas Ashbaugh and Tom Shumilak), 34, 36, 38–39 (Minnie's Country House exterior photographed by Garth Vaughan).

Handcar on page 28 reproduced from *All Aboard: The Wonderful World of Disney Trains* (Disney Editions, 2015) and courtesy Clifford Herbst.

This book's producers would also like to thank Justin Arthur, Jennifer Black, Michael Buckhoff, Fox Carney, Joy Childs, Becky Cline, Monique Diman, Dennis Ely, Winnie Ho, Kevin Kern, Warren Meislin, Betsy Mercer, Greta Miller, Christina Novak, David Pacheco, Scott Piehl, Steve Plotkin, Michael Serrian, Ken Shue, Betsy Singer, Dave Smith, Muriel Tebid, Marybeth Tregarthen, Dushawn Ward, and Jessie Ward.

ISBN 978-1-4847-6773-3

FAC-029191-16225

Printed in Malaysia

First Edition, September 2016

10 9 8 7 6 5 4 3 2 1

Visit www.disneybooks.com

D23
The Official Disney Fan Club
D23.com

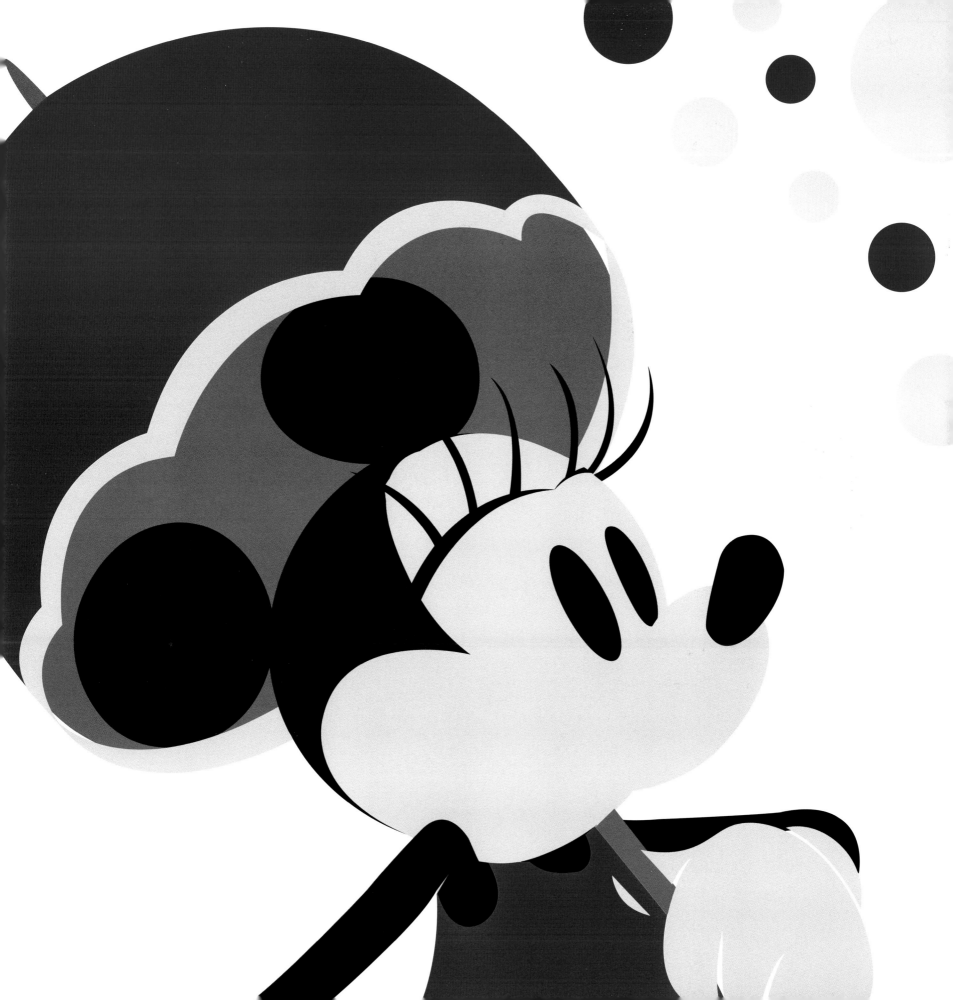

Table of Contents

Section One

Her Animated Filmography . . .

A comprehensive collection cataloging
Minnie Mouse's animated appearances

Section Two

Her Milestones . . .

Memorable moments and key turning points
in the life and times of Minnie Mouse

Section Three

Her Gallery . . .

Interpretations of Minnie Mouse from artists of
Disney Consumer Products and Interactive Media

*"When you look back
across the decades of Minnie's career,
it's apparent she's always been able to hold her
own as a unique personality. Even today, with recent
appearances in* Get a Horse! *(2013), the* Mickey Mouse
television shorts, and the Kingdom Hearts *video games,
Minnie is a thespian who performs far beyond the range
of 'just' ink and paint. Cute, sometimes quirky, and
rarely afraid to get in on the action, she's just as
much an interesting character and role model
now as she was in 1928 and fully capable
of saving the day."*

—**Becky Cline, Director,
Walt Disney Archives**

SECTION ONE

Her Animated Filmography

A comprehensive collection
cataloging Minnie Mouse's
animated appearances

Her Animated Filmography

Dates reflect general delivery, U.S. release, or airdate.

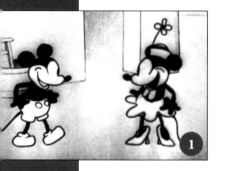

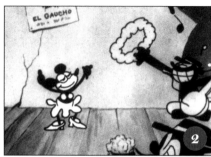

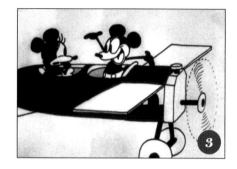

1. **Steamboat Willie**
(Mickey Mouse cartoon short)
November 18, 1928

2. **The Gallopin' Gaucho**
(Mickey Mouse cartoon short)
1928

3. **Plane Crazy**
(Mickey Mouse cartoon short)
1928

4. **The Barn Dance**
(Mickey Mouse cartoon short)
1928

5. **When the Cat's Away**
(Mickey Mouse cartoon short)
1929

6. **The Plowboy**
(Mickey Mouse cartoon short)
1929

7. **The Karnival Kid**
(Mickey Mouse cartoon short)
1929

8. **Mickey's Follies**
(Mickey Mouse cartoon short)
1929

9. **Mickey's Choo-Choo**
(Mickey Mouse cartoon short)
1929

10. **Wild Waves**
(Mickey Mouse cartoon short)
1929

11. **The Cactus Kid**
(Mickey Mouse cartoon short)
May 15, 1930

12. **The Fire Fighters**
(Mickey Mouse cartoon short)
June 25, 1930

13. **The Shindig**
(Mickey Mouse cartoon short)
July 29, 1930

14. **The Gorilla Mystery**
(Mickey Mouse cartoon short)
October 10, 1930

15. **The Picnic**
(Mickey Mouse cartoon short)
October 23, 1930

16. **Pioneer Days**
(Mickey Mouse cartoon short)
December 5, 1930

17. **The Birthday Party**
(Mickey Mouse cartoon short)
January 7, 1931

18. **Traffic Troubles**
(Mickey Mouse cartoon short)
March 17, 1931

19. **The Delivery Boy**
(Mickey Mouse cartoon short)
June 13, 1931

20. **Mickey Steps Out**
(Mickey Mouse cartoon short)
July 7, 1931

21. **Blue Rhythm**
(Mickey Mouse cartoon short)
August 18, 1931

22. **The Barnyard Broadcast**
(Mickey Mouse cartoon short)
October 10, 1931

23. **The Beach Party**
(Mickey Mouse cartoon short)
November 5, 1931

24. **Mickey Cuts Up**
(Mickey Mouse cartoon short)
November 30, 1931

• Her Animated Filmography •

25. **Mickey's Orphans**
(Mickey Mouse cartoon short)
December 9, 1931

26. **The Grocery Boy**
(Mickey Mouse cartoon short)
February 11, 1932

27. **Barnyard Olympics**
(Mickey Mouse cartoon short)
April 15, 1932

28. **Mickey's Revue**
(Mickey Mouse cartoon short)
May 25, 1932

29. **Musical Farmer**
(Mickey Mouse cartoon short)
July 9, 1932

30. **Mickey in Arabia**
(Mickey Mouse cartoon short)
July 18, 1932

31. **Mickey's Nightmare**
(Mickey Mouse cartoon short)
August 13, 1932

32. **The Whoopee Party**
(Mickey Mouse cartoon short)
September 17, 1932

33. **Touchdown Mickey**
(Mickey Mouse cartoon short)
October 15, 1932

34. **The Wayward Canary**
(Mickey Mouse cartoon short)
November 12, 1932

35. **The Klondike Kid**
(Mickey Mouse cartoon short)
November 12, 1932

36. **Building a Building**
(Mickey Mouse cartoon short)
January 7, 1933

37. **Mickey's Pal Pluto**
(Mickey Mouse cartoon short)
February 18, 1933

38. **Mickey's Mellerdrammer**
(Mickey Mouse cartoon short)
March 18, 1933

39. **Ye Olden Days**
(Mickey Mouse cartoon short)
April 8, 1933

40. **The Mail Pilot**
(Mickey Mouse cartoon short)
May 13, 1933

41. **Mickey's Mechanical Man**
(Mickey Mouse cartoon short)
June 17, 1933

42. **Mickey's Gala Premiere**
(Mickey Mouse cartoon short)
July 1, 1933

43. **Puppy Love**
(Mickey Mouse cartoon short)
September 2, 1933

44. **The Steeple Chase**
(Mickey Mouse cartoon short)
September 30, 1933

45. **The Pet Store**
(Mickey Mouse cartoon short)
October 28, 1933

46. **Shanghaied**
(Mickey Mouse cartoon short)
January 13, 1934

47. **Camping Out**
(Mickey Mouse cartoon short)
February 17, 1934

48. **Mickey's Steam-Roller**
(Mickey Mouse cartoon short)
June 16, 1934

49. **The Dognapper**
(Mickey Mouse cartoon short)
November 17, 1934

50. **Two-Gun Mickey**
(Mickey Mouse cartoon short)
December 15, 1934

51. **On Ice**
(Mickey Mouse cartoon short)
September 28, 1935

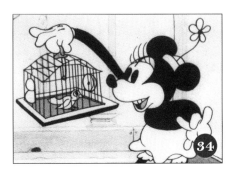
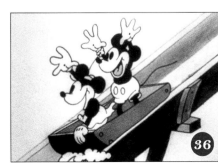
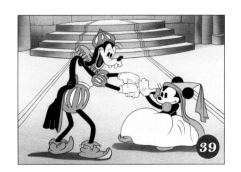
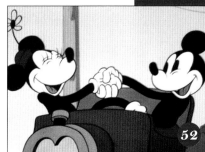

The Art of Minnie Mouse

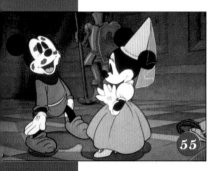 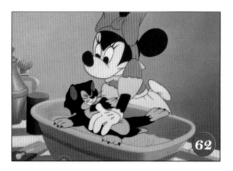 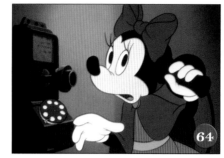

52. Mickey's Rival
(Mickey Mouse cartoon short)
June 20, 1936

53. Hawaiian Holiday
(Mickey Mouse cartoon short)
September 24, 1937

54. Boat Builders
(Mickey Mouse cartoon short)
February 25, 1938

55. Brave Little Tailor
(Mickey Mouse cartoon short)
September 23, 1938

56. Mickey's Surprise Party
(commercial cartoon short)
February 18, 1939

57. The Little Whirlwind
(Mickey Mouse cartoon short)
February 14, 1941

58. The Nifty Nineties
(Mickey Mouse cartoon short)
June 20, 1941

59. Mickey's Birthday Party
(Mickey Mouse cartoon short)
February 7, 1942

60. Out of the Frying Pan into the Firing Line
(cartoon short made for the U.S. government during World War II)
July 30, 1942

61. First Aiders
(Pluto cartoon short)
September 22, 1944

62. Bath Day
(Figaro cartoon short)
October 11, 1946

63. Figaro and Frankie
(Figaro cartoon short)
May 30, 1947

64. Mickey's Delayed Date
(Mickey Mouse cartoon short)
October 3, 1947

65. Pluto's Sweater
(Pluto cartoon short)
April 29, 1949

66. Pluto and the Gopher
(Pluto cartoon short)
February 10, 1950

67. Crazy Over Daisy
(Donald Duck cartoon)
March 24, 1950

68. Pluto's Christmas Tree
(Mickey Mouse cartoon short)
November 21, 1952

69. A 1955 Nash Rambler car commercial
(animated sequence within a live-action television commercial)
1955

70. Mickey Mouse Club
(animated opening sequence of the live-action television series)
October 3, 1955–September 25, 1959

71. The Mouse Factory
(live-action animated television series featuring classic Disney animated cartoon shorts)
January 26, 1972–1974

72. The "new" Mickey Mouse Club
(animated opening sequence of the live-action television series)
January 17, 1977–December 1, 1978

73. Mickey Mouse Disco
(animated television music video short featuring classic Disney animated cartoon shorts)
June 25, 1980

74. Mickey's Christmas Carol
(Mickey Mouse cartoon featurette)
December 16, 1983

75. DTV
(animated television music video series featuring classic Disney animated cartoon shorts)
May 5, 1984–1985

76. Disney's DTV Valentine
(animated television music video special featuring classic Disney animated cartoon shorts)
February 14, 1986 (re-aired as Disney's DTV Romancin' September 7, 1986)

• Her Animated Filmography •

77. Disney's DTV Doggone Valentine
(animated television music video special featuring classic Disney animated cartoon shorts)
February 13, 1987

78. Disney's DTV Monster Hits
(animated television music video special featuring classic Disney animated cartoon shorts)
November 27, 1987

79. Disney's Totally Minnie
(live-action and animated television special)
March 25, 1988

80. 60th Annual Academy Awards
(live-action awards show with a special segment featuring Disney animated characters in tribute to Mickey Mouse's sixtieth birthday)
April 11, 1988

81. Who Framed Roger Rabbit
(live-action and animated feature)
June 22, 1988

82. Mickey's 60th Birthday
(live-action and animated television special)
November 13, 1988

83. Runaway Brain
(Mickey Mouse cartoon short)
August 11, 1995

84. Mickey MouseWorks
(animated television series)
May 1, 1999–January 6, 2001

85. Mickey's Once Upon a Christmas
(direct-to-home-video animated feature)
November 9, 1999

86. "Pomp and Circumstance, Marches 1, 2, 3, and 4" Fantasia/2000
(animated feature)
January 1, 2000

87. Disney's House of Mouse
(animated television series)
January 13, 2001–February 2009

88. Mickey's Magical Christmas: Snowed in at the House of Mouse
(direct-to-home-video animated feature)
November 6, 2001

89. Mickey's House of Villains
(direct-to-home-video animated feature)
September 3, 2002

90. The Three Musketeers
(direct-to-home-video animated feature)
August 17, 2004

91. Mickey's Twice Upon a Christmas
(direct-to-home-video CG animated feature)
November 9, 2004

92. Mickey Mouse Clubhouse
(CG animated television series)
May 5, 2006–present

93. Minnie's Bow-Toons
(CG animated television shorts)
November 14, 2011–present

94. Disney Electric Holiday
(cartoon short made for Barneys New York and unveiled in the windows of its Madison Avenue flagship store)
November 14, 2012

95. Mickey Mouse
(animated online/television series)
March 8, 2013–present

96. Get a Horse!
(CG and traditional animated Mickey Mouse cartoon short)
November 27, 2013

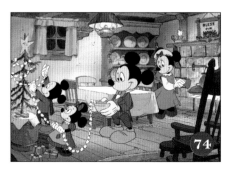

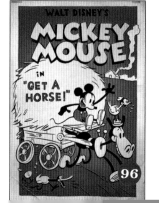

SECTION TWO

Her Milestones

Memorable moments and key
turning points in the life and
times of Minnie Mouse

Her Milestones

Dates reflect general delivery, U.S. release, or airdate.

● **May 15, 1928:** A preview of the first completed Mickey Mouse silent short, *Plane Crazy*, screens with live piano accompaniment at a movie house in Hollywood. *Plane Crazy* was completely drawn by animator Ub Iwerks, while Walt Disney closely worked with him on the story and character personalities. In this and other early Mickey Mouse shorts, vocals for Minnie are voiced by Walt himself.

BELOW LEFT: Ub Iwerks, circa 1930; **BELOW RIGHT:** Walt Disney

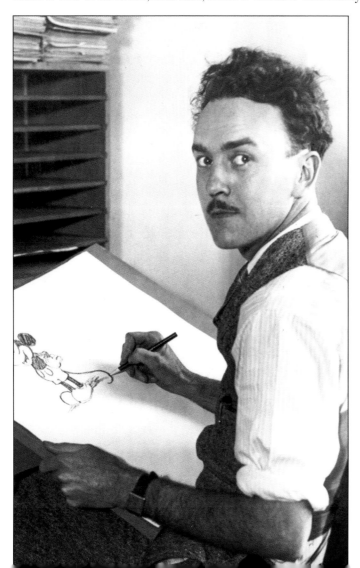 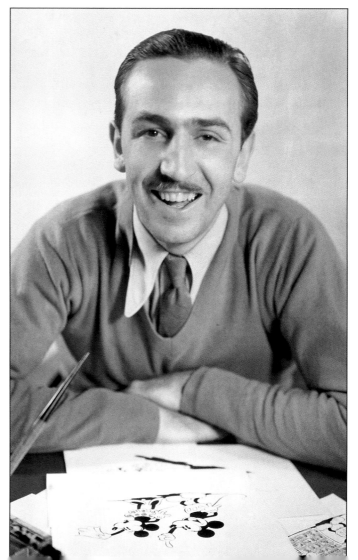

PLANE CRAZY PLOT:
Minnie gives Mickey a lucky horseshoe before he takes flight on the maiden voyage of his newly built airplane, and he invites her along for the ride. But when Mickey gets thrown from the cockpit, Minnie is left alone aboard the runaway plane for some animated antics. Mickey soon reboards and regains control of the craft—only to request

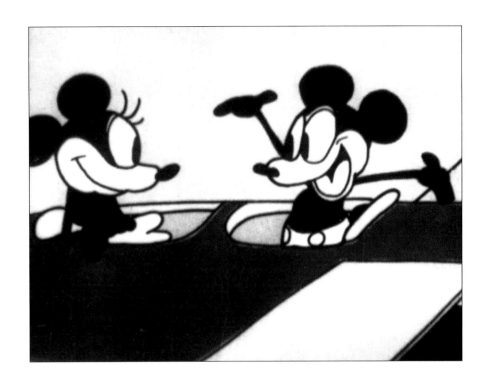

a kiss from Minnie. When Minnie refuses, Mickey whirls the plane in a loop-the-loop and then steals a kiss. Minnie gives him a slap, jumps out, and parachutes to the ground using her bloomers. Mickey is so distracted that he accidentally crashes the plane. Luckily, a tree breaks his fall—and he's ultimately left alone with Minnie's horseshoe charm.

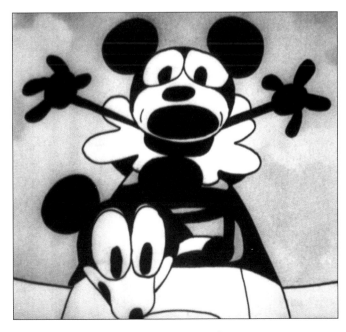

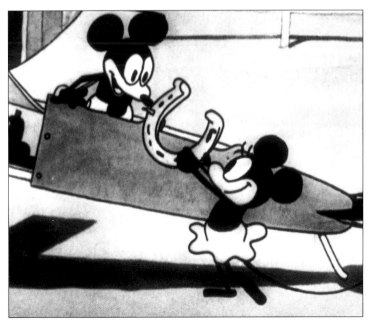

TOP AND ABOVE: Final frames from *Plane Crazy,* 1928

• **November 18, 1928:** The first official Mickey Mouse short, *Steamboat Willie*—complete with animation's first fully synchronized sound track—premieres at New York City's Colony Theatre.

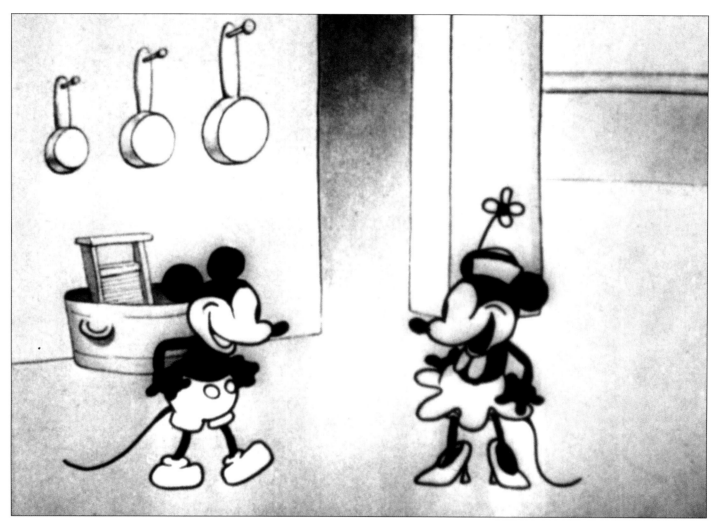

ABOVE: Final frame from *Steamboat Willie*, 1928; **OPPOSITE:** Story script pages from the same short

***STEAMBOAT WILLIE* PLOT:** Mickey is a deckhand on a paddle steamer captained by mean ol' Pete. Shortly after the ship docks at a river landing, Minnie races across the countryside in hopes of boarding the vessel. She just misses them and runs along the bank until she catches Mickey's attention and he hoists her aboard using a crane. In the process, Minnie's fiddle and sheet music fall onto the deck where a goat promptly eats

(6)

...ow with large
...stomach....
...with pitchfork
...rams it down her
...stomach....it fills
...she fits the belt
...she pulls fork out
...she is raised
...Mickey turns...

Scene # 12.....after
...irted with milk and the
...back onto wharf he tries
...elt before he sees hay
...after it.

...t of old pig laying on
...lower part covered by
...ont of her. Mickey runsin
...t her with smile on face.
...is for crane...rope with
...ere into room...he puts it
...ig and fastens it....gives
...when it starts to lift
...then it makes sound) then as she
...ed up from behind box it rev-
...er of little pigs hanging
...bits....they are squirming
...Hold cycle of
...queeling in air before taking
...suspended in air before taking
...scene. Mickey watches with smile.
...effects of GRUNT and SQUEALS.

...ne # 16.

...dium shot road pan. of little
...male mouse (Minnie Mouse)
...running along road in a hurry.
...he has ukulele in one hand and
...oll of music in other. she waves
...and yells as she runs.
...she has on skirt and goofy little
...hat with flower on it.

Sound effects..... when she yells
the sound ' YOO--HOO ' could be
made by some instrument.

(7)

Scene # 17.

L.S. of wharf and river (same as
Scene # 11.) Boat is loaded and
ready to start....Mickey gives a
signal and hops on as it whistles.
(same goofy whistle) The smoke
stacks squat down and the body of boat
swells out....then as stacks shoot
up the body gets skinny (effect of
it taking deep breath and puffing
it out) as the smoke shoots out the
paddle wheels turn and it goes off
scene puffing. Just as it goes off
the little girl runs onto wharf and
yells (hops up and down) then she
jumps over onto the shore and runs
off scene after boat 'yelling etc'

Scene # 18.

Perspective pan river....rear end of
boat...

(8)

...cabin
...itchen
...tensils
...old
...beside
...Kitchen '
...rom
...ops in
...e air
...ell
...pek
...t...
...ts.

...k
...front

...watches it as it
...er....he looks at it in queer
...anner....his mouth waters as he
licks lips..... His long tongue
comes out and wraps around sheet
and pulls it into his mouth and he
starts chewing.

Scene # 22.

Back to shot of girl dangling from
hook (same as # 20) the hook
lowers her down to deck and she lands
on hands and feet with fanny in air.
The hook unhooks from pants and
starts of scene...it notices her
skirt still in air....it reaches
over and pulls it down over her
fanny.....as hook goes off scene
the girl gets up and turns to pick up
her music.....she sees goat eating
it and ' screams ' Mickey runs in
scenestops and looks off scene
in surprised manner.

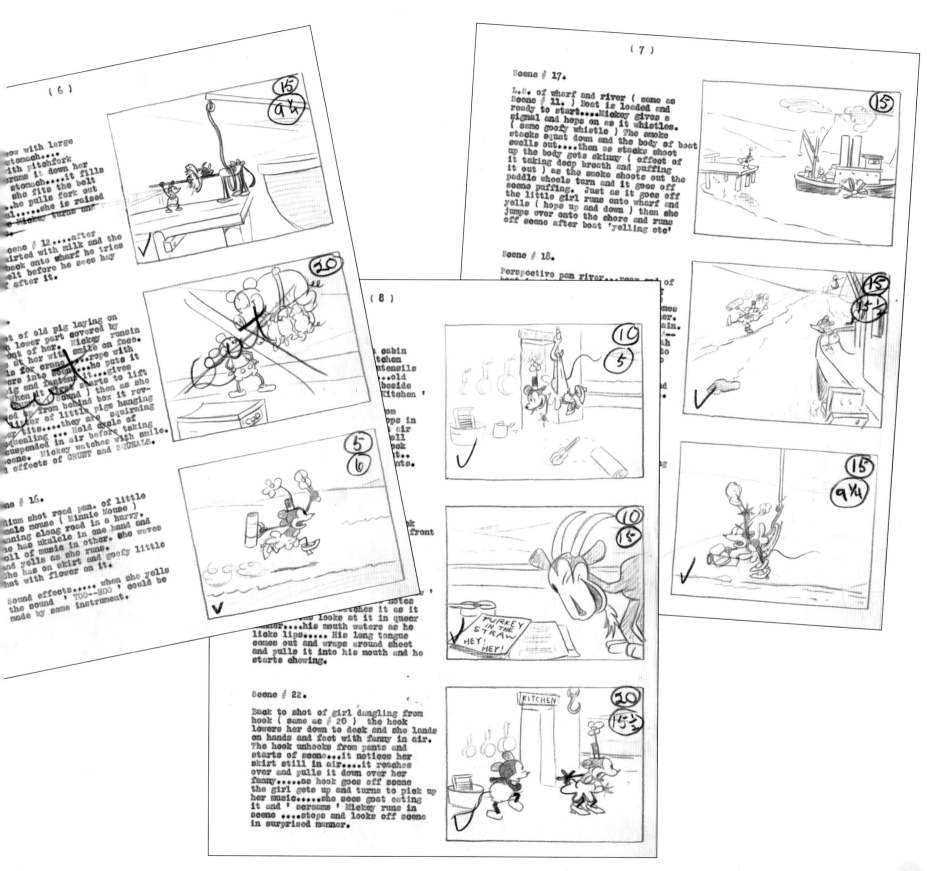

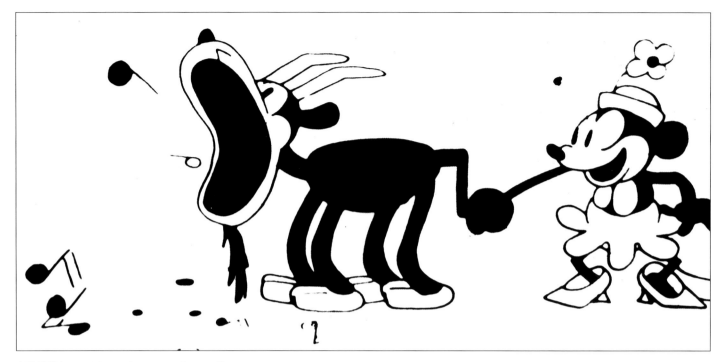

ABOVE: Final frame from *Steamboat Willie*, 1928

them. Minnie is able to make merriment of the situation by winding the goat's tail (like an old gramophone spinning a record) and playing "Turkey in the Straw." Mickey enlists other animals to add to the musical festivities—until an unhappy Pete throws Mickey into the galley to peel potatoes.

● **Later in 1928:** The second official Mickey Mouse short, *The Gallopin' Gaucho*, is released and features Minnie and Mickey's first on-screen dance and kisses.

***The Gallopin' Gaucho* Plot:** Mickey, as *El Gaucho*, meets Minnie at the *Cantino Argentino* establishment where they dance together and fall in love. But when nefarious Pete kidnaps Minnie, Mickey boards his loyal (if not exactly noble) ostrich and follows them. He ultimately engages Pete in a swordfight—and wins. The victorious Mickey escapes with Minnie, who then offers him a kiss. Unfortunately, the bumpy ride aboard the ostrich makes it difficult for them to kiss properly. Soon they share the same idea of using their tails as springs to cushion the ride. Finally, they happily share a steady kiss until out of view.

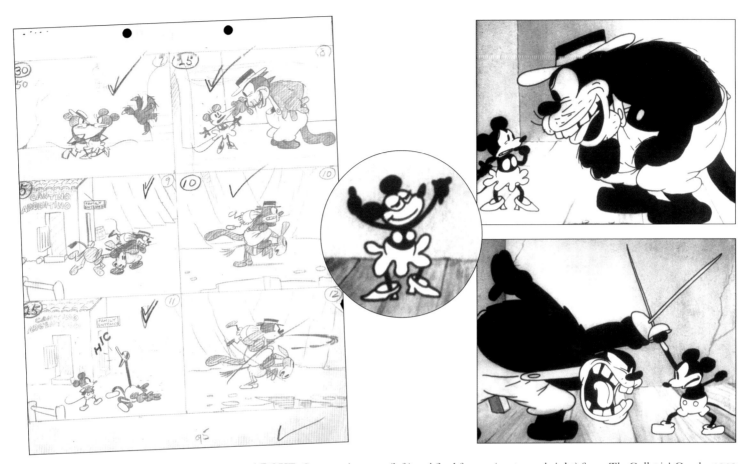

ABOVE: Story script page (left) and final frames (center and right) from *The Gallopin' Gaucho*, 1928

● **1929:** Release of the first Mickey Mouse short with spoken dialogue (in addition to music and sound effects), *The Karnival Kid* occurs. In it, Minnie has two lines. The first is "Yoo-hoo" (to catch the attention of Mickey, who plays the hot dog vendor at a carnival). The second is "Eeny, meeny, miny, moe" when she is choosing which hot dog she would like to order.

● **Later in 1929:** Release of the Mickey Mouse short *Mickey's Follies*, which debuted Mickey singing the soon-to-be famous song "Minnie's Yoo Hoo." Mickey performs this ode to Minnie from a makeshift orchestra pit near a rough-and-ready stage in the farmyard. Minnie herself sings the first "yoo-hoo" from her box seat—made, naturally, from an actual wooden box setting on the ground. "Minnie's Yoo Hoo," written by Walt Disney and Carl Stalling, went on to become the first Disney song ever to be published

on sheet music and also later served as the original theme song for the *Mickey Mouse Club.*

● **Later still in 1929:** The Mickey Mouse short *Mickey's Choo-Choo* is released and features Minnie and Mickey's first full conversation with each other. Their dialogue is:

 Mickey: *Hello.*
 Minne: *Hello.*
 Mickey: *Whatcha got?*
 Minnie: *Fiddle.*
 Mickey: *Can you play it?*
 Minnie: *Uh-huh.*

● **Circa 1930:** As Minnie continues to have more dialogue within the Mickey Mouse shorts, Walt stops voicing the female mouse and hires Marcellite Garner from the animation division's Ink and Paint Department to be Mickey's leading lady. Marcellite voiced Minnie into the 1940s.

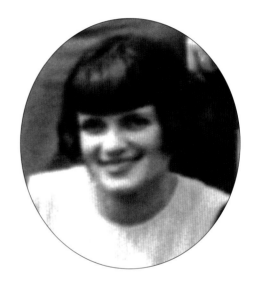

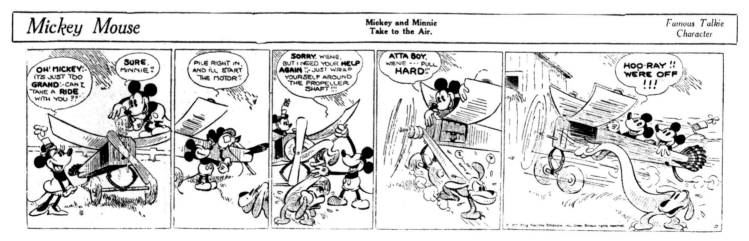

ABOVE: Voice actress for Minnie Mouse, Marcellite Garner, circa 1930 (top) and the comic strip titled "Mickey and Minnie Take to the Air" from the Mickey Mouse comic "Lost on a Desert Island;" story by Walt Disney; pencils by Ub Iwerks; inks by Win Smith (bottom); **OPPOSITE:** Ub and Win from a 1929 Walt Disney Studio group portrait (top); front covers of David McKay's *The Adventures of Mickey Mouse: Book 1* (below left) and Bibo-Lang's *Mickey Mouse Book* (below right)

• **January–March, 1930:** Walt Disney, Ub Iwerks, and Win Smith create the Mickey Mouse newspaper comic strip story called "Lost on a Desert Island," marking Minnie's debut in comics. The plot begins in a similar way to the one in *Plane Crazy*, but Mickey in the comic crashes his plane on a desert island instead of a farm. From there, more adventures ensue until Mickey and Minnie reunite. Ub drew the strip until Win took it over.

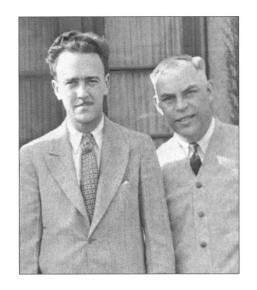

• **1931:** Publisher David McKay releases the first hardcover Disney book, *The Adventures of Mickey Mouse: Book 1*, and both Minnie and Mickey make the front cover. Minnie is inked and colored so that her outfit is comprised of white gloves, a yellow pillbox hat with a yellow-and-red flower, a yellow skirt with red polka dots, and green shoes. The only book to be released prior to this was more akin to a paperback pamphlet called *Mickey Mouse Book*; it was published by Bibo-Lang in 1930 and featured Mickey alone on the cover.

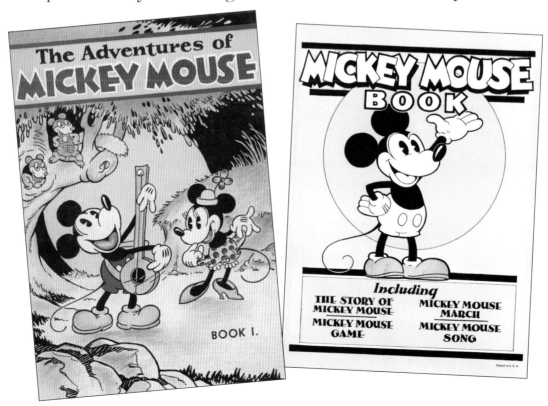

• **November 12, 1932:** The Mickey Mouse short *The Klondike Kid* is released and demonstrates how the story lines between Minnie and Mickey became deeper over time. In one scene, a freezing Minnie weeps as Mickey takes her inside, out of the snowstorm. Their dialogue is:

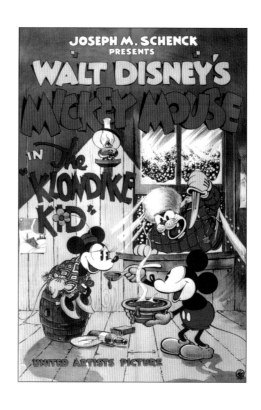

Mickey: *Hello.*

Minnie: (weeping) *Hello.*

Mickey: *Who are you?*

Minnie: (weeping continues) *I'm nobody.*

Mickey: *Ain't you got no folks?*

Minnie: (weeping continues; frustration begins) *Nobody.*

Mickey: *Just an orphan?*

Minnie: (weeping and frustration intensify) *Just nobody!*

Mickey: *Me too. . . . Guess we're both nobodies.*

(Minnie and Mickey laugh together at the shared connection.)

• **1933:** Release of the first issue of *Mickey Mouse Magazine,* a precursor to the modern-day Mickey Mouse comic book, which prominently features Minnie on the cover along

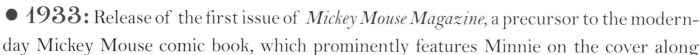

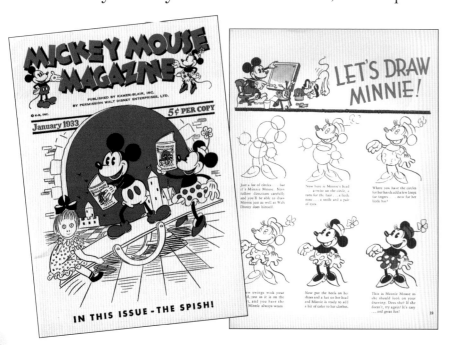

with Mickey. The magazine would be released in a more elaborate format in 1935. Minnie would make the cover along with ten fellow characters—among them: Donald Duck, Pluto, Goofy, and of course an oversized Mickey. She would be inked and colored so that her outfit consists of red gloves and her classic red skirt (albeit with yellow polka dots) and yellow shoes.

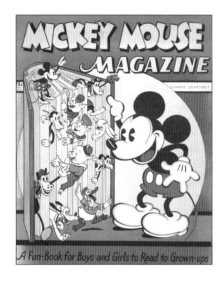

● **April 8, 1933:** Minnie first portrays the role of a princess in the Mickey Mouse short *Ye Olden Days*. Years later, in 1938, she would take on that part again in one of her most iconic roles as Princess Minnie in the Mickey Mouse short *Brave Little Tailor*. In contemporary times, she would play a princess in both the direct-to-home-video animated feature *The Three Musketeers* in 2004 and the *Mickey Mouse Clubhouse* special "Minnie-rella" in 2014, as well as a queen in the 2002 *Kingdom Hearts* video game.

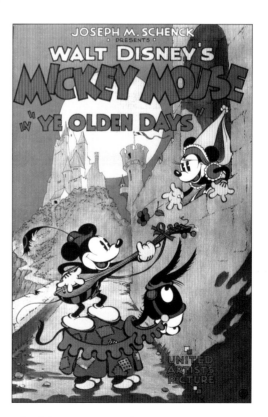

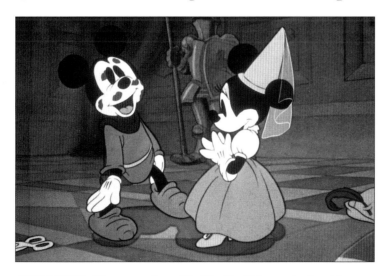

OPPOSITE: Film poster from *The Klondike Kid*, 1932 (top) and front cover of the first issue of *Mickey Mouse Magazine*, January 1933 (below left) with an interior page offering a drawing lesson from a later issue in summer 1935: volume 1, number 1, page 19 (below right);
ABOVE: *Mickey Mouse Magazine* front covers from summer 1935: volume 1, number 1 (top left); March 1940: volume 5, number 6 (top center); and March 1937: volume 2, number 6 (top right); final frame from *Brave Little Tailor*, 1938 (bottom left) and film poster from *Ye Olden Days*, 1933 (bottom right)

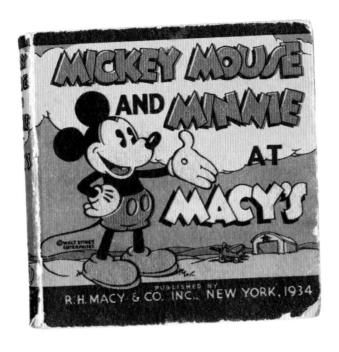

● **1934:** Release of the first book with Minnie in the title, *Mickey Mouse and Minnie at Macy's*, a promotional publication. However, despite the title, Minnie didn't make front cover; only Mickey was pictured.

● **January 22, 1935:** The New York Times publishes an article titled "Mickey Mouse Saves Jersey Toy Concern; Carries it Back to Solvency on His Railway." The article describes how the Lionel Company sold more than two hundred and fifty thousand little mechanical toys known as the Mickey Mouse Handcar in 1934—credited as the key factor in bringing the company out of bankruptcy and helping it become the world's largest toy manufacturer in the 1950s. Of course . . . Mickey couldn't have pumped along those toy tracks without Minnie as his partner.

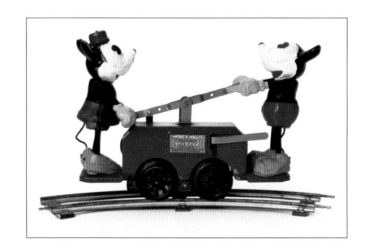

● **September 28, 1935:** Minnie debuts in her first Technicolor Mickey Mouse short, *On Ice*. Her outfit features a red pillbox hat with a yellow flower, a yellow skirt with white polka dots, red mittens, and white shoes with ice skates.

● **June 20, 1936:** The release of Minnie's second Technicolor Mickey Mouse short, *Mickey's Rival*, brings the film debut of Minnie's quintessential yellow shoes—paired with a red pillbox hat and white flower, a solid light-blue skirt, and white gloves. It also establishes the smarmy Mortimer Mouse as Minnie's ex-boyfriend before she and Mickey

became sweethearts. (Mortimer was one of the original names that Walt considered for his cartoon mouse, and it's Walt's wife, Lillian, who is credited with not liking it and instead suggesting the name Mickey.)

• **1938:** Whitman publishes the first book solely about Minnie, *Walt Disney's Story of Minnie Mouse.* Minnie is presented on the front cover wearing yellow gloves, a light-blue skirt with red polka dots, and her memorable yellow shoes.

• **February 18, 1939:** The delivery date of *Minnie's Surprise Party,* a commercial cartoon made for the National Biscuit Company (aka Nabisco). The film debuted at the 1939 New York World's Fair and featured Minnie's first typical giant bow atop her head. (This one, bright blue.)

• **1940s–1950s:** Other voice actresses take on the role of Minnie's voice, including Thelma Boardman and later Ruth Clifford.

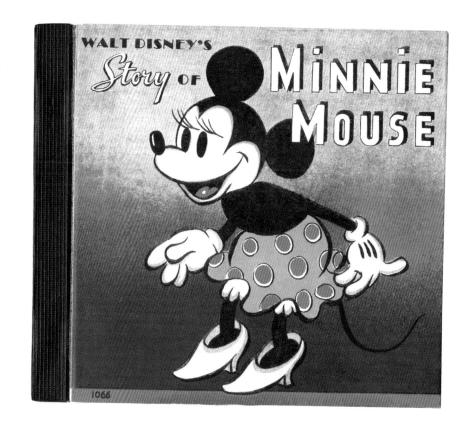

WALT DISNEY'S
Story OF MINNIE MOUSE

1066

OPPOSITE: Front cover of *Mickey Mouse and Minnie at Macy's* (top left) and photograph of the antique toy known as the Mickey Mouse Handcar (center right); **ABOVE:** Final frame from *Mickey's Rival,* 1936 (top left) and front cover of Whitman's *Walt Disney's Story of Minnie Mouse* (bottom right)

• January 19–May 2, 1942:

Merrill De Maris and Floyd Gottfredson create the Mickey Mouse comic strip story called "The Gleam." In the January 23 comic, Minnie is referred to as Minerva Mouse. Minnie's official name has always been Minnie Mouse, although many fans of the comic universe still perk up when they hear a "Minerva" reference. (See a nod to the comic in Ryan Wood's artwork on page 131.)

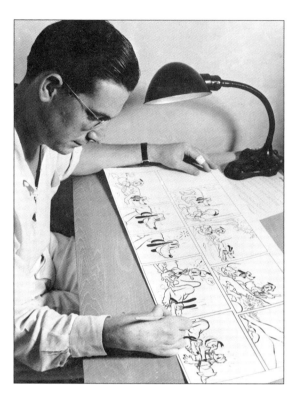

RIGHT: Floyd Gottfredson, in August 1937, working on the Mickey Mouse comic strip; **BELOW:** January 23, 1942 comic strip from the Mickey Mouse comic "The Gleam"; story by Merrill De Maris; pencils by Floyd; inks by Bill Wright; **OPPOSITE:** Film poster from *First Aiders*, 1944

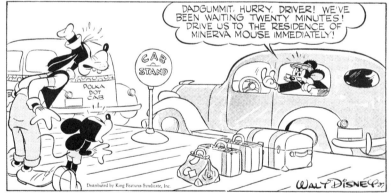

• July 30, 1942:

The delivery date of the cartoon short *Out of the Frying Pan into the Firing Line*, made for the U.S. government during World War II. It features Minnie and Pluto urging people to save cooking grease and turning it over to Official Fat Collecting Stations to aid the war effort. It also marks the first cartoon to star Minnie without Mickey (although there is a quick photograph of him donning a military uniform).

● **September 22, 1944:** Minnie's debut in her first officially branded Pluto cartoon short, *First Aiders*. The film also introduces Figaro the cat from the 1940 full-length animated feature *Pinocchio* as Minnie's pet. Furthermore, it's the first time Minnie dons a full dress (outside of period costumes) instead of just a skirt.

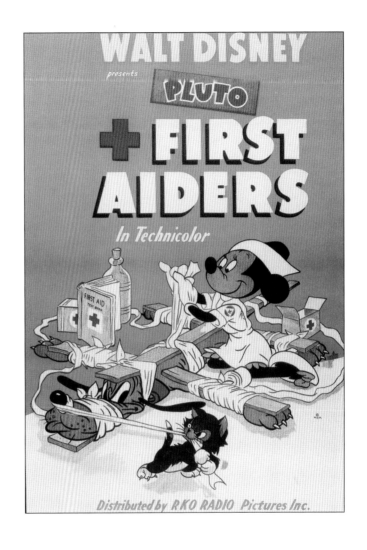

FIRST AIDERS PLOT: Minnie practices her nursing skills at home and asks Pluto and Figaro if one of them would help her. Wanting Minnie's attention, Figaro rushes ahead of Pluto, but Pluto deviously knocks Figaro into a wash bucket. Minnie hears the crash and scolds Figaro for making a mess, not knowing Pluto's involvement. Meanwhile, Pluto happily helps Minnie, and she praises him until she ultimately leaves to pick up more supplies. She warns the pair not to get into any trouble while she's out, but of course Figaro takes advantage of the situation and seeks his revenge on Pluto (who Minnie left wrapped in bandages). Soon, Pluto chases Figaro throughout the house and yard, and Minnie returns to see Pluto falling down the stairs. She aids the now-injured dog, and Figaro laughs so hard that he loses control and falls down the stairs, too, getting tangled in a bandage. In the end, Minnie encourages the two to make amends.

● **October 11, 1946:** Minnie's first officially branded Figaro cartoon short, *Bath Day*, features Minnie's film debut of her wearing a pink bow and dress (with exceptions for themed costumes like her princess dress in *Brave Little Tailor*).

● **October 3, 1947:** The Mickey Mouse cartoon short *Mickey's Delayed Date* is released and offers the first hint of Minnie in a red dress, albeit with no polka dots and tattered and torn as part of a "Hard Times Costume Party" outfit.

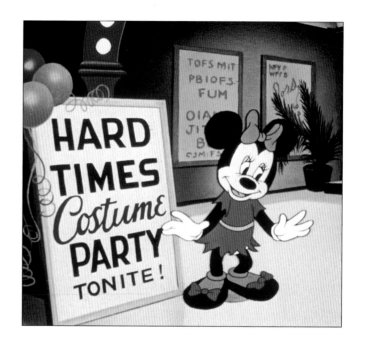

● **July 17, 1955:** Disneyland opens in Anaheim, California. With it, costumed versions of Disney characters greet guests at the Park, a tradition that has since become a staple. In this form, Minnie, naturally, would join Mickey as a lead ambassador of Disneyland—and of all Disney Parks that have followed. The very first Disney character costumes (including Minnie's) were actually not created by Disney. The company borrowed them from John Harris's Ice Capades, which had a Disney segment in their shows.

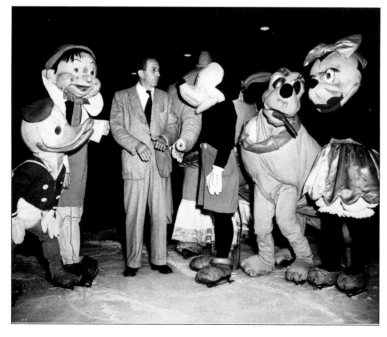

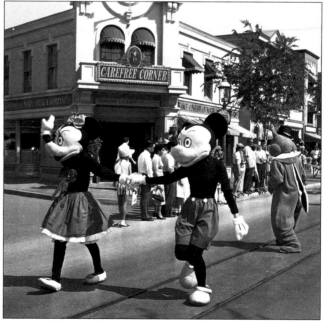

● **October 3, 1955:** The *Mickey Mouse Club* debuts on television. The show's animated opening sequence features Minnie with Mickey, Dumbo, Jiminy Cricket, and others. Like Daisy Duck, Minnie wears a drum majorette ensemble. In the "new" *Mickey Mouse Club* that followed in the 1970s, her outfit was colorized to be pink.

Also of note is that the *Mickey Mouse Club* popularized the now-iconic mouse ears hat. Roy Williams and the male Mouseketeers wore what's come to be understood as the traditional mouse ears style, and female Mouseketeers (including Annette Funicello) wore a style with a bow on top—like Minnie. Inspired by the show, the Benay-Albee Novelty Co. was first to produce the hat for sale at Disneyland, so the fashion-driven mouse ears and headbands that trumpet Minnie's style and are so popular today can be traced to this television origin.

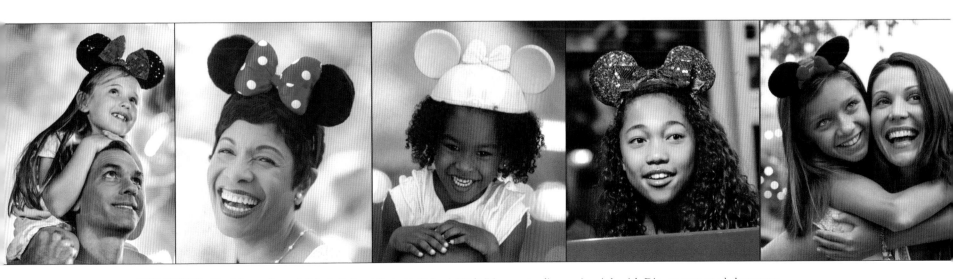

OPPOSITE: Final frame from *Mickey's Delayed Date*, 1947 (top); Walt Disney, standing on ice rink with Disney costumed characters from the Ice Capades, circa 1955 (bottom left); costumed characters Minnie and Mickey leading a parade down Disneyland's Main Street, U.S.A. in June 1958 (bottom right); **FAR ABOVE:** Final frame from the animated opening sequence of *Mickey Mouse Club*, showcased in color for the "new" series in 1977; **ABOVE:** Modern-day examples of Minnie Mouse ears at the Disney Parks

• **March 6, 1980:** The television special *Kraft Salutes Disneyland's 25th Anniversary* airs with Danny Kaye as the special host. Minnie, as a costume character, appears in her customary dress and bow in red with white polka dots and her classic yellow shoes. The outfit debuted at the Parks prior to this, but by this point it's established as her main style.

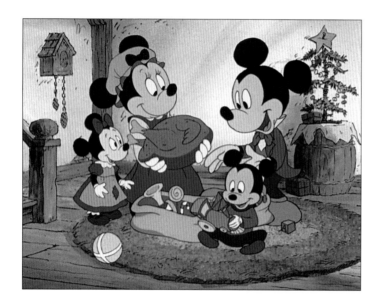

• **December 16, 1983:** Minnie's first cartoon featurette, *Mickey's Christmas Carol*, portrays Minnie in the role of Mrs. Cratchit in the Disney-themed holiday rendition of the 1843 novella *A Christmas Carol* by Charles Dickens.

• **1986:** Walt Disney Productions dubbs this year Minnie's year and aims to give her duly deserved recognition as a cornerstone Disney character. Minnie is updated with a rock 'n' roll 1980s fashion style, more than a hundred entertainers perform in the summerlong Totally Minnie Parade at Disneyland, and the *Totally Minnie* music album is released.

• **1987:** Famed American fashion photographer Herb Ritts takes the now famous black-and-white portrait of singer and actress Madonna, at age 29, sitting in bed wearing Minnie Mouse ears atop her head. The photo embodies the turning point in history when Minnie Mouse—and her style—transcended Disney products and became an iconic fashion symbol.

• **February 13, 1987:** *Disney's DTV Doggone Valentine,* an animated television

music video special featuring classic Disney animated cartoon shorts, is released and offers some new dialogue dubbed over older animation to act as a transition between clips. Around this time, Russi Taylor would begin to do the voice recording for Minnie. To date, Russi continues to be Minnie's official voice actress. In 1991, she married Wayne Allwine, who voiced Mickey Mouse for a number of years. In 2008, a year before Wayne passed away, both of them were honored as Disney Legends.

OPPOSITE: Final frame from *Mickey's Christmas Carol*, 1983 (top); costumed character Minnie from the 1986 Disney Parks Totally Minnie Parade (center right); **ABOVE:** Russi Taylor, current voice of Minnie, with Wayne Allwine, former voice of Mickey (left) and with their costumed character counterparts at the 2008 Disney Legends ceremony (right)

• **March 25, 1988:** The television special *Disney's Totally Minnie* is released and features Minnie's debut as an animated character within live-action footage and also marks the first special with her name in the title text. The only other series to date with Minnie in the title is the preschool-focused Minnie's Bow-Toons television shorts on Disney Junior.

DISNEY'S TOTALLY MINNIE PLOT: A stereotypical 1980s nerd (equipped with a pocket-pen protector, thick black-frame glasses, and klutzy mannerisms) named Maxwell Dweeb, played by Robert Carradine, needs help. Maxwell sees an ad for the Minnie Mouse Center for the Totally Unhip and enrolls in the training program— taught by the center's director (played by Suzanne Somers) and an animated version of

ABOVE: Cover of the Disneyland Records album *Totally Minnie*, 1986
BELOW: Minnie Moo, the female Holstein cow, formerly at Walt Disney World

Minnie. Minnie's lessons aim to bring out the best in oneself and to "turn your dull world upside down." Among her schooling points: develop a good sense of rhythm. (A music video duet of Elton John and an animated Minnie singing and dancing to "Don't Go Breaking My Heart" at the Santa Monica Pier in Southern California emphasizes this.) In the end, Maxwell takes the messages to heart and becomes "really cool." Minnie's final note—delivered through a clip of Walt Disney himself—is to ultimately "be yourself" and you'll become the greatest version of you that you can be.

• **April 11, 1988:** Minnie, in her animated form, attends the *60th Annual Academy Awards* hosted by comedian Chevy Chase. She is seen in the front row of the audience (seated next to Donald Duck and Daisy Duck and drawn wearing a pink evening gown) during a special segment celebrating Mickey's sixtieth birthday. Chevy introduces a clip reel about Mickey—which includes Minnie from the *Brave Little Tailor*—and then welcomes the animated mouse to the stage. Finally, Mickey introduces his co-presenter, Tom Selleck, and the two announce the Best Animated Short Film award.

• **June 18, 1988:** Grandma Duck's Farm in the Magic Kingdom at Walt Disney World opens. The petting zoo is perhaps best remembered for its female Holstein cow (named Minnie Moo because of her a white coat and a black Mickey Mouse head silhouette on her

side), which joined the crew in 1990. In 1996, the area would be transformed, and Minnie Moo would move to a petting farm at Tri-Circle D Ranch in Disney's Fort Wilderness Resort and Campground. Minnie Moo died in 2001, and soon after a memorial plaque was mounted in the barn. To date, guests can still visit it.

● **June 22, 1988:** Minnie's first cameo in a full-length theatrical feature, *Who Framed Roger Rabbit.* Thus far, this and her second cameo in the "Pomp and Circumstance, Marches 1, 2, 3, and 4" sequence of *Fantasia/2000* mark her only full-length theatrical feature appearances.

● **November 20, 1989:** Minnie joins the Disney Dollars currency legacy when she is first added to the $10 bill, alongside Mickey on the $1 bill and Goofy on the $5 bill. Over the years, Minnie also pops up on bills themed to special occasions, such as the opening of Disney California Adventure.

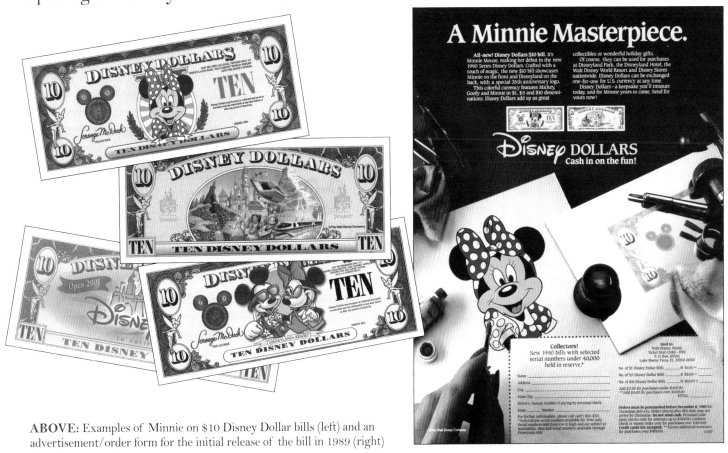

ABOVE: Examples of Minnie on $10 Disney Dollar bills (left) and an advertisement/order form for the initial release of the bill in 1989 (right)

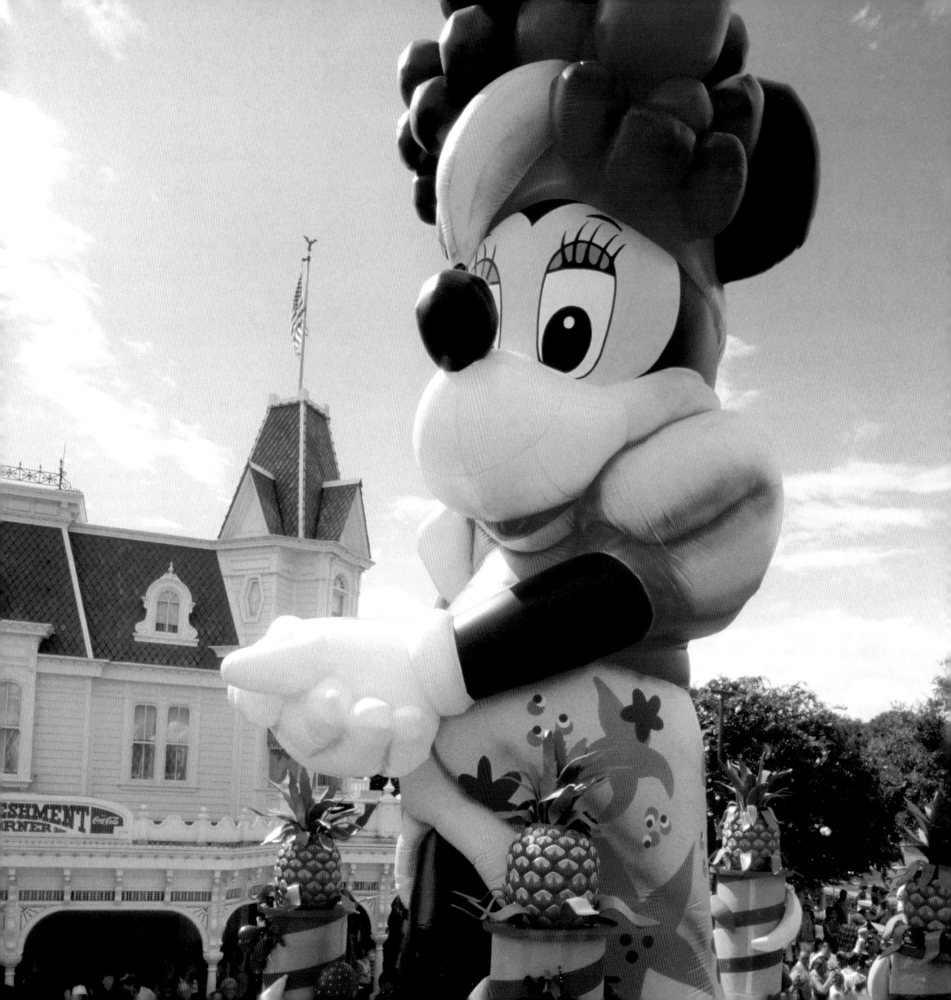

● **January 11, 1990:** The Mardi Gras-themed Party Gras Parade begins at Disneyland and runs till November 18. Among the stilt-walkers and other elaborately costumed performers are giant floats towering over the buildings on Main Street, U.S.A. Minnie is one such memorable float, dressed in an outfit inspired by Carmen Miranda, a legendary film star of the 1940s. A similar parade, Surprise Celebration Parade, with an identical Minnie float, would run in the Magic Kingdom at Walt Disney World from September 1991-June 1994; likewise the Party Gras Parade also would take up residence at Tokyo Disneyland from April 1991-April 1993.

● **January 24, 1993:** Minnie's House opens in Mickey's Toontown at Disneyland and offers guests the chance to walk through a cartoon world come to life. A highlight is Minnie's "diet cookies," which feature a hologram of chocolate chip cookies on a plate. Mickey's Toontown Fair in the Magic Kingdom at Walt Disney World would open a duplicate version of her house, dubbed Minnie's Country House, that remained open until the area closed in February 2011 to make room for the Fantasyland expansion. To date, Minnie's House at Tokyo Disneyland is still open.

OPPOSITE: Minnie balloon float in the Magic Kingdom at Walt Disney World during the twentieth anniversary Surprise Celebration Parade, an identical float to the one from Disneyland's Party Gras Parade; **ABOVE:** Exterior (left) and interior (right) of the now-retired Minnie's Country House in the Magic Kingdom at Walt Disney World

• **November 9, 1999:** Minnie's first direct-to-home-video animated feature, *Mickey's Once Upon a Christmas*, is released and showcases Mickey and Minnie in a story sequence based on O. Henry's 1906 classic short story, "The Gift of the Magi."

• **November 9, 2004:**
Minnie's first appearance in computer-generated animation with the direct-to-home-video animated feature *Mickey's Twice Upon a Christmas*. This animation technique would be refined and later used in the 2006 television series *Mickey Mouse Clubhouse* and the 2011 Minnie's Bow-Toons television cartoon shorts for preschoolers.

• **April 2008:** The Russian edition of the fashion and lifestyle magazine *Vogue* runs an eight-page feature on Minnie Mouse couture. As told through a loose story line, costumed character Minnie takes a vacation to Moscow, and model Masha Tyelna takes her to see the sites—both of them dressed to the nines. The shoot was photographed by Doug Inglish and styled by Sally G. Lyndley. Minnie's outfits, exclusively created by a variety of Russian fashion designers, are inspired by the likes of Russian nesting dolls, the *Swan Lake* ballet, Russian folk dancing, and even modern art.

• **March 8, 2013:** Although considered Minnie's most classic outfit, when it came to theatrical and televised animated appearances, it is not until the animated online/television series *Mickey Mouse* debut that Minnie dons a red pillbox hat with a yellow flower, a red skirt with white polka dots, and yellow shoes.

● **July 29, 2013:** The glossy British fashion and lifestyle publication *LOVE Magazine* releases its 475-page, fifth anniversary issue, and Minnie Mouse is the cover star. One of the cover variations features a costumed character Minnie from a photo shoot by Mert Alas and Marcus Piggott. Other covers feature celebrities Edie Campbell, Cara Delevinge, Rosie Huntington-Whiteley, and Georgia May Jagger modeling Minnie-inspired mouse ears exclusively made by luxury fashion designers Loewe, Gucci, Marc by Marc Jacobs, and Miu Miu, respectively. Model Chiharu Okunugi also poses in an oversized plaid shirt and mouse ears by Jake and Dinos Chapman for Louis Vuitton.

● **November 27, 2013:** With the return of a theatrical Mickey Mouse short *Get a Horse!* Minnie appears in both her computer-generated and traditional animation forms. Minnie's dialogue in the film is a combination of old recordings of Marcellite Garner voicing the character and new lines performed by Russi Taylor.

● **January 22, 2016:** Minnie Rocks the Dots, a year-long marketing campaign, kicks off in Los Angeles with an interactive fashion and art installation heralding the iconic character's signature style. In attendance are famed fashion designer Christian Siriano, who designed a custom dress for costumed character Minnie, along with actress Sarah Hyland (*Modern Family*), who was seen rocking her dots in celebration!

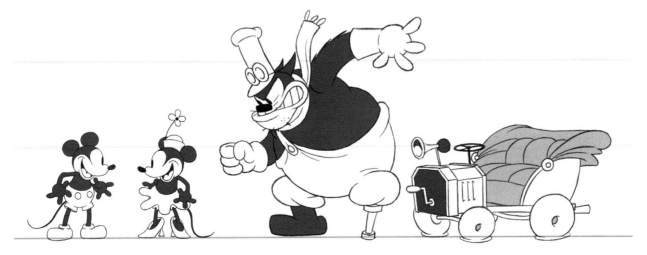

OPPOSITE: Final frame from *Mickey's Twice Upon a Christmas*, 2004 (center right) and Mickey and Minnie character art from the animated series *Mickey Mouse*, 2013 (bottom left); **ABOVE:** Character lineup, drawn by director Eric Goldberg, illustrating the height differences among Mickey, Minnie, Pete, and the car for the Mickey Mouse short *Get a Horse!*, 2013

SECTION THREE

Her Gallery

Interpretations of Minnie Mouse
from artists of Disney Consumer Products
and Interactive Media

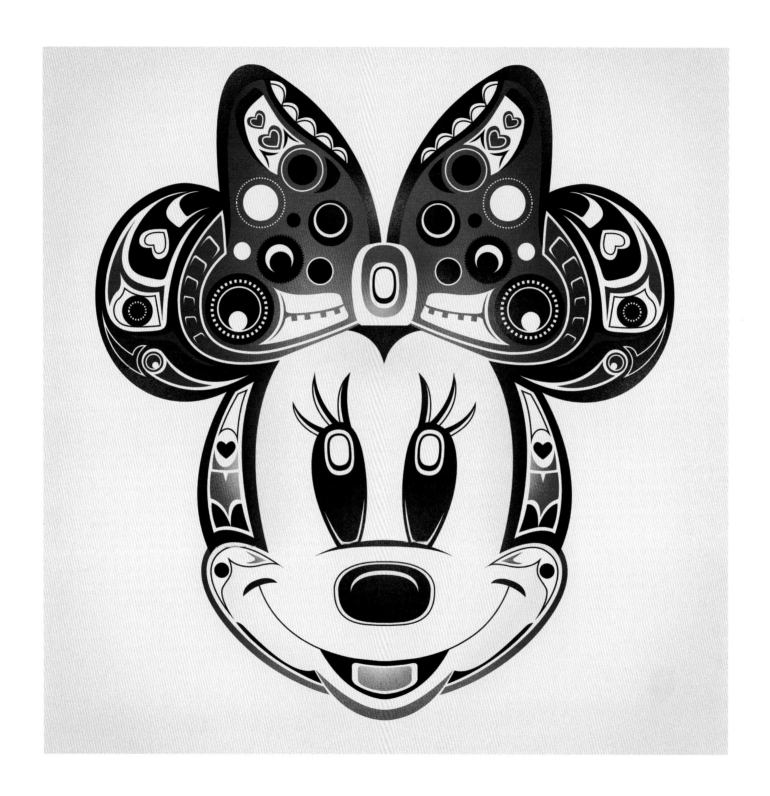

STEPHANIE CHOW

MEDIUM: digital

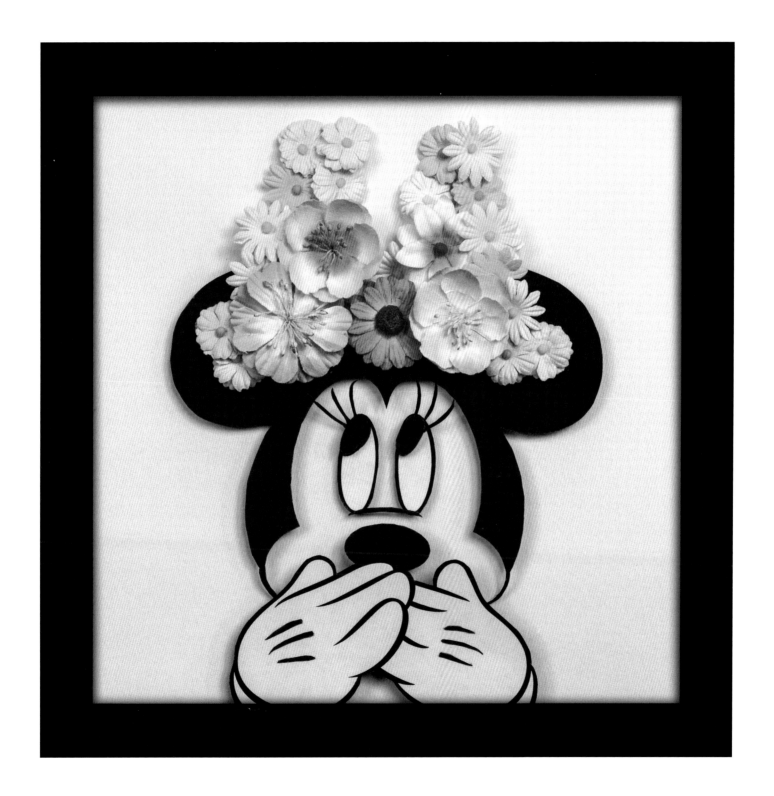

Diana Tran
Medium: mixed media (cardstock paper, tacky glue, and floral in a shadow box)

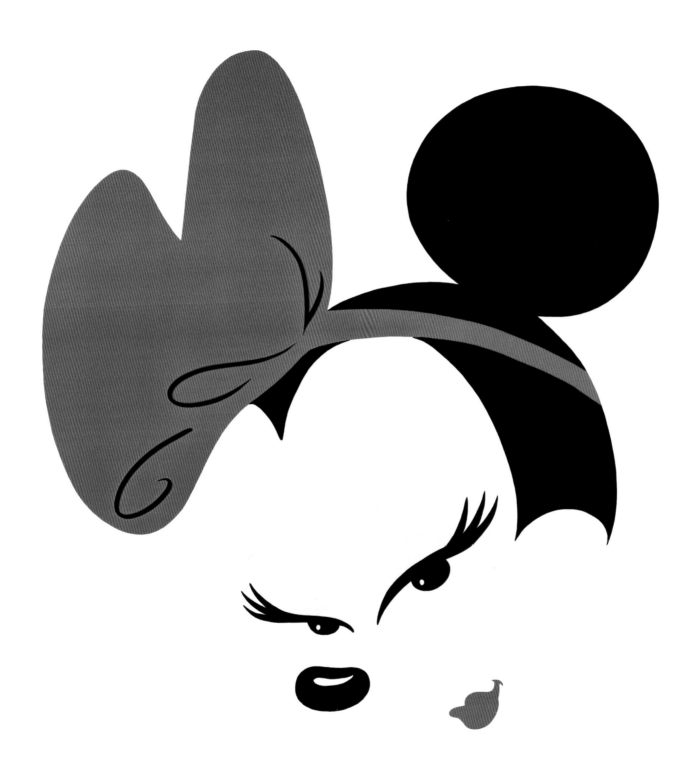

DAVID PACHECO

MEDIUM: digital

DAVID PACHECO
MEDIUM: digital

ALYSON KAYNE

MEDIUM: digital photography

48

CATHY CLARK

MEDIUM: digital

• Her Gallery •

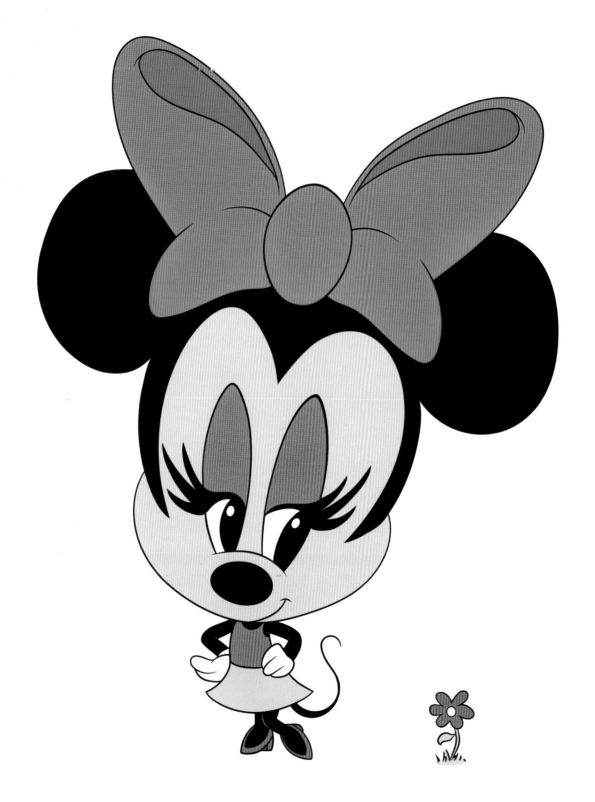

ANTHONY WHITFELD
MEDIUM: digital

• Her Ears •

*"My earliest memory was when I was three years old,
loving a pair of Minnie Mouse ears my mom
put on my head. They blew my mind.
I was a costume kid, so I loved accessories."*

—Zoë Kravitz, actress and singer

As exclusively told to *Grazia* magazine and reported in the
Celebrity News column *"Zoë Kravitz reveals stylish childhood,"*
People magazine, June 2, 2013

• Her Gallery •

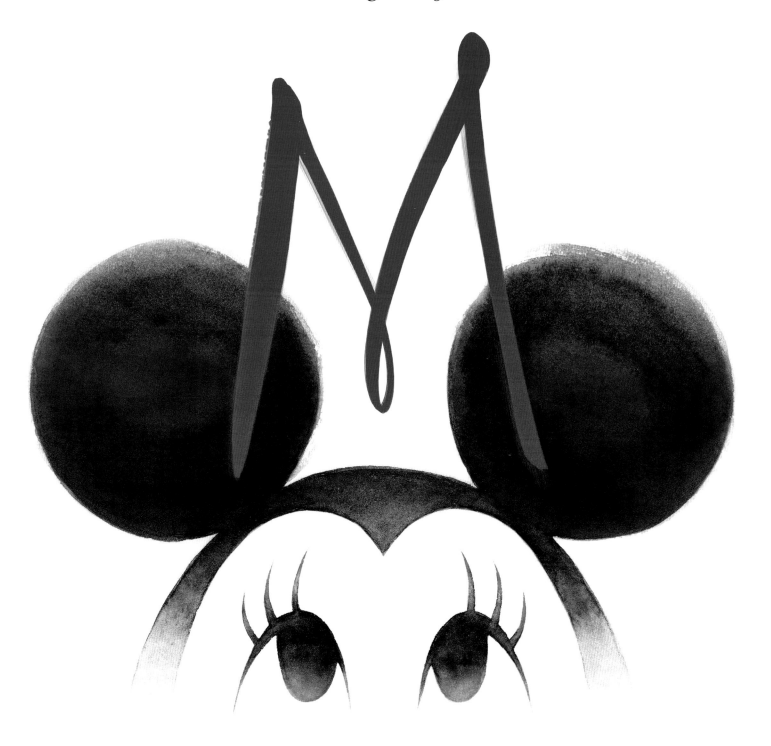

Eric Tan

MEDIUM: watercolor and acrylic

• Her Ears •

"Before the shoot, I told them that my only request was that I get ears. And the seamstress on set actually made them for me! I still have them; I kept them."

—Lauren Conrad, actress and fashion designer, on the photo shoot session that featured her in clothes from her Minnie-inspired LC Lauren Conrad collection for Kohl's

As exclusively told to Rose Walano and Ingrid Meilan for the article "Lauren Conrad Unveils Her Minnie Mouse Collection for Kohl's: Get Your First Look at the Adorable Designs!," Us Weekly magazine, April 8, 2015

• Her Gallery •

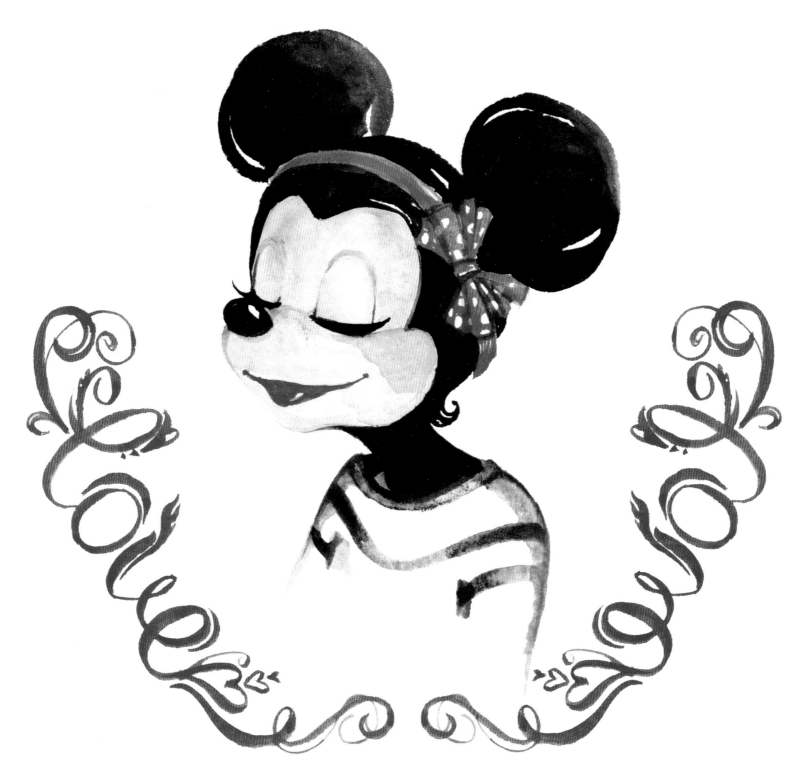

DARIA VINOGRADOVA
MEDIUM: watercolor

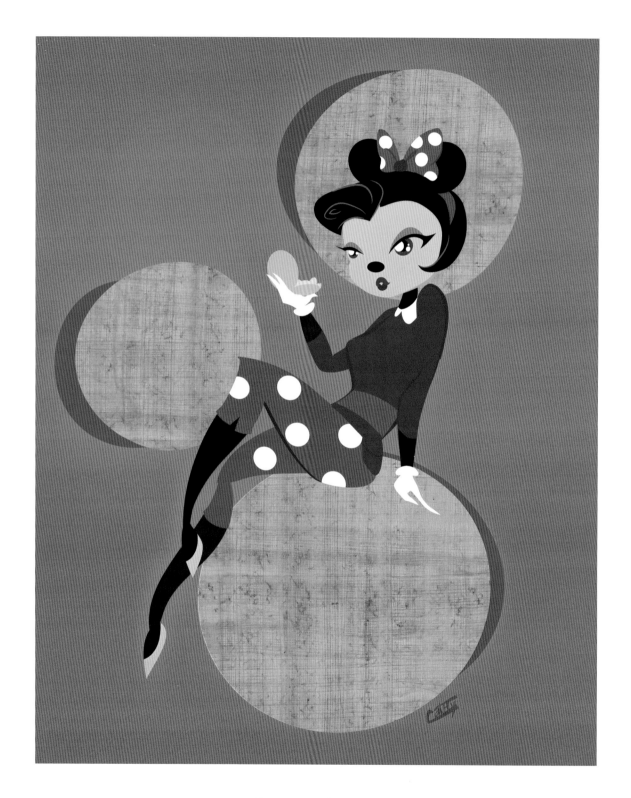

CATHY CLARK

MEDIUM: digital

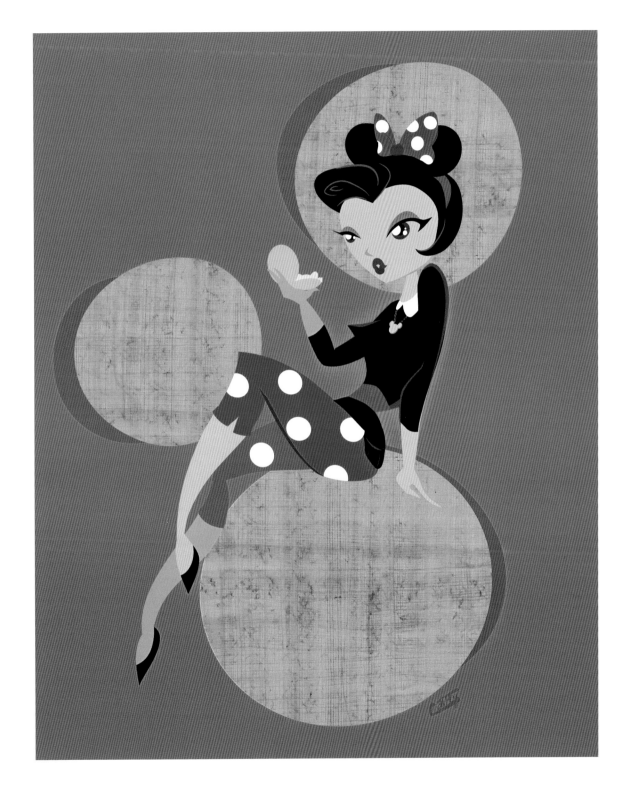

CATHY CLARK

MEDIUM: digital

• Her Ears •

*"I do not know why I am wearing Minnie Mouse
ears other than the fact that there is no reason
for me not to wear them."*

—Genevieve Hannelius, teen actress and singer-songwriter

As posted by herself on her instagram account, June 2014

• Her Gallery •

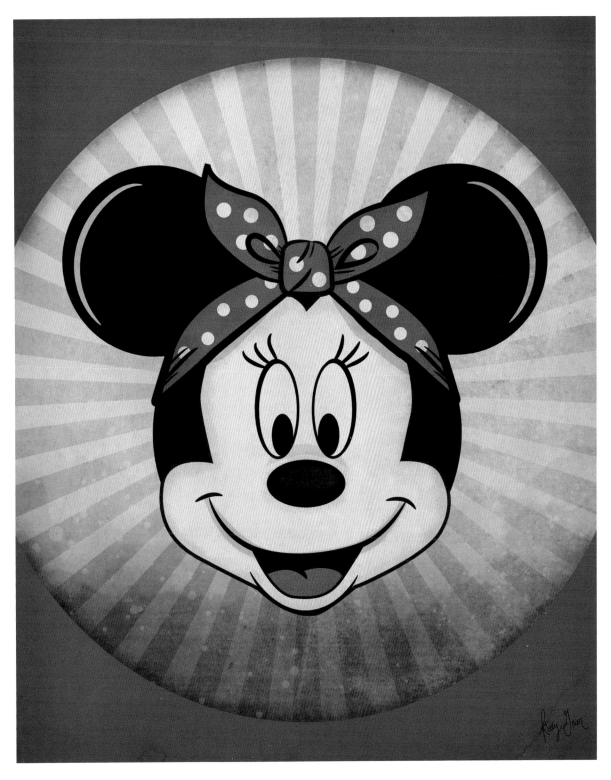

KITTY GRIER
MEDIUM: digital

ANDREW TAYLOR
MEDIUM: digital

ANDREW TAYLOR
MEDIUM: digital

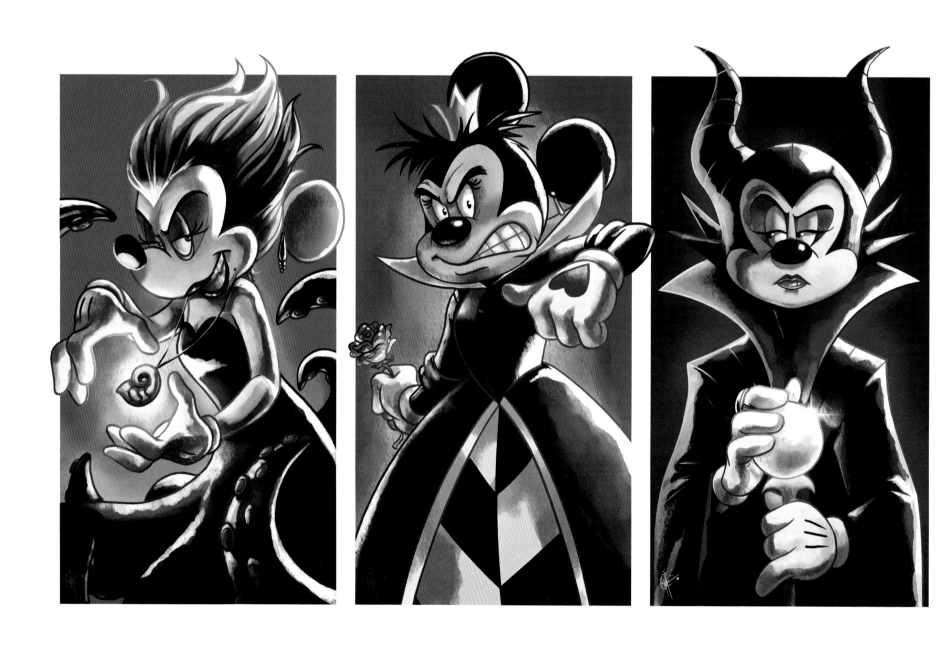

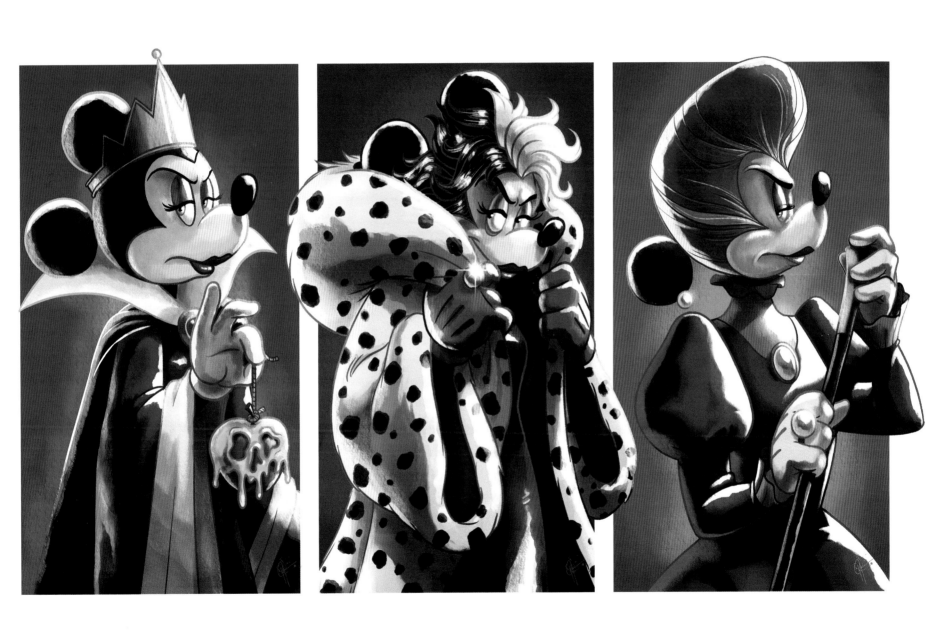

JEFFREY THOMAS
MEDIUM: digital

• Her Legacy •

"Mickey and Minnie are the host and hostess of the Magic Kingdom in every Park; when they welcome guests there, they are welcoming them into their own home. [. . .] Over time, the walk-around characters' design evolved, just as their animated forms always have. [. . .] I later had a lot of fun designing costume for Minnie, especially for special occasions such as Minnie's Day."

—John Hench, artist, designer, Imagineer, and Disney Legend, with Peggy Van Pelt, author and spokesperson

FROM *DESIGNING DISNEY: IMAGINEERING AND THE ART OF THE SHOW*, DISNEY EDITIONS, 1994

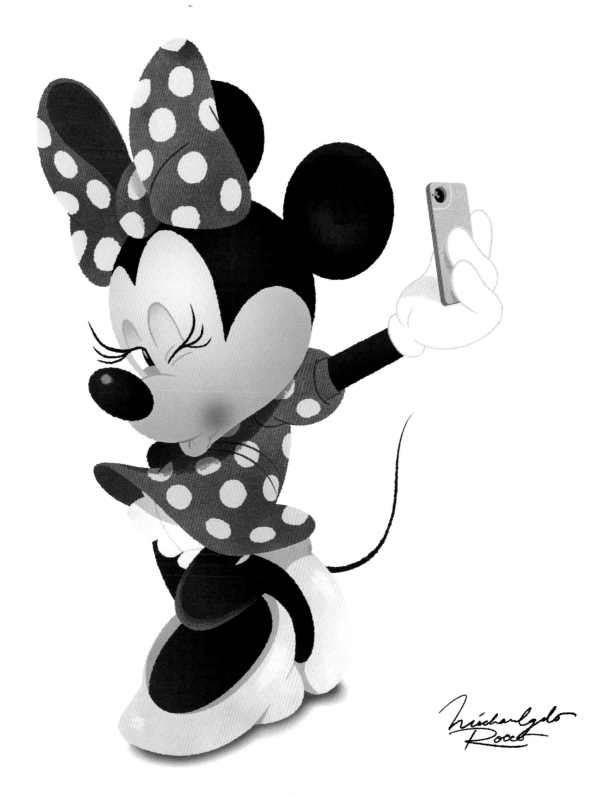

MICHAELANGELO ROCCO
MEDIUM: digital

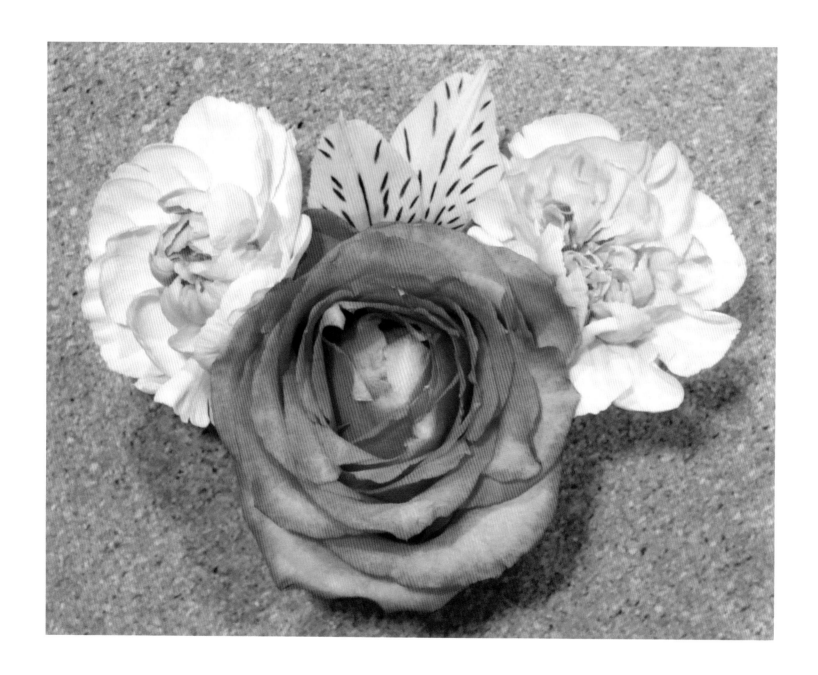

JENNIFER EASTWOOD

MEDIUM: mixed media (fresh flowers on corkboard)

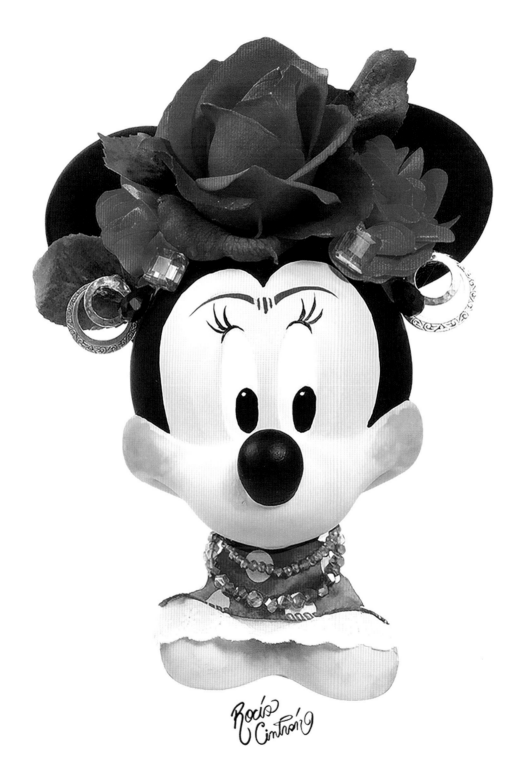

Rocío Cintron

MEDIUM: mixed media (vinyl, acrylic, and gouache)

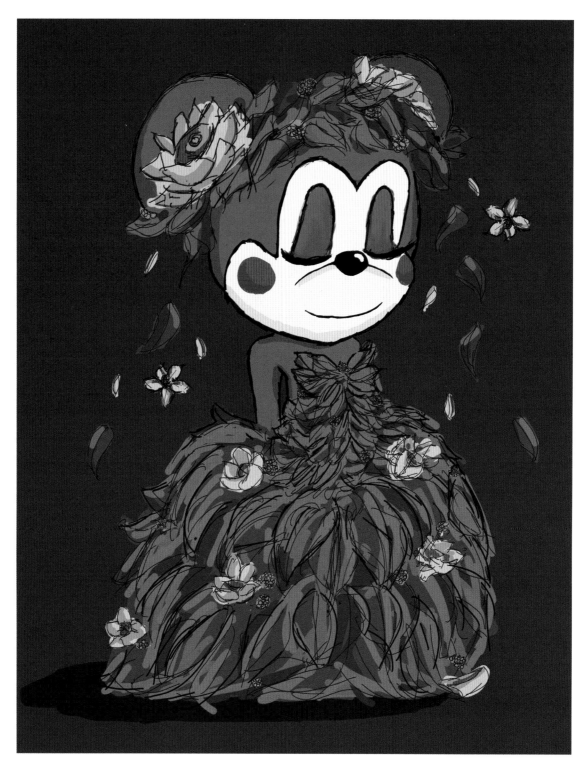

Annie Sae-Hoon

MEDIUM: digital

• Her Confidence •

"Mickey Mouse and Minnie Mouse are not only favorite Disney characters; they represent optimism, goodwill, and happiness."

—Beth Moeri, chief merchandising officer, Pandora, Americas

As reported by PR Newswire in the article "Pandora Jewelry's New Disney Themed Collection Celebrates Mickey Mouse And Minnie Mouse" thestreet.com, December 5, 2014

• Her Confidence •

*"What she [Minnie] represents is unbelievable.
She's always been an independent woman.
Minnie means girl power."*

—Kelly Osbourne, co-host of the E! television network's *Fashion Police*

As reported by the Disney Blog "Minnie Mouse: Style Icon,"
January 30, 2014

ANTHONY WHITFELD
MEDIUM: digital

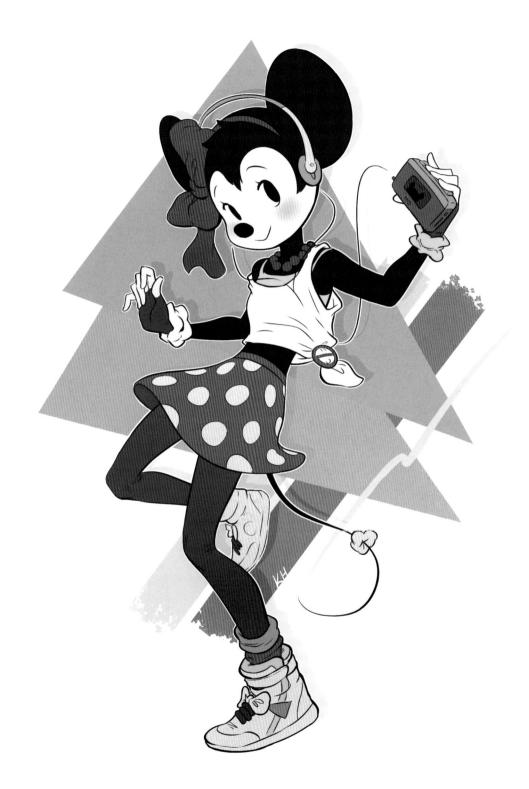

KELLY HAMILTON

MEDIUM: digital

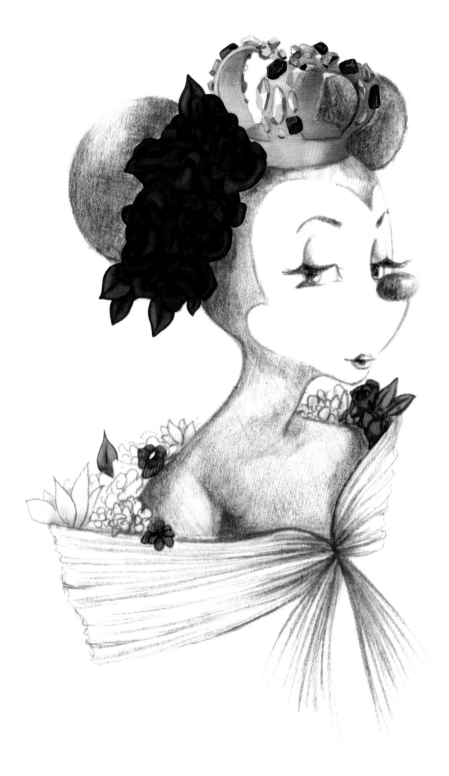

KATHY YOON

MEDIUM: mixed media, graphite pencil, and digital

• Her Confidence •

*"Minnie, the leading lady of Disney, personifies
the spirit of femininity. She moves, speaks, and acts gracefully.
She is intelligent, independent, and a positive role model.
Most of all, she enjoys life to the fullest."*

—David Pacheco, creative director, Disney Consumer Products

As reported by the Disney Blog "Minnie Mouse: Style Icon,"
January 30, 2014

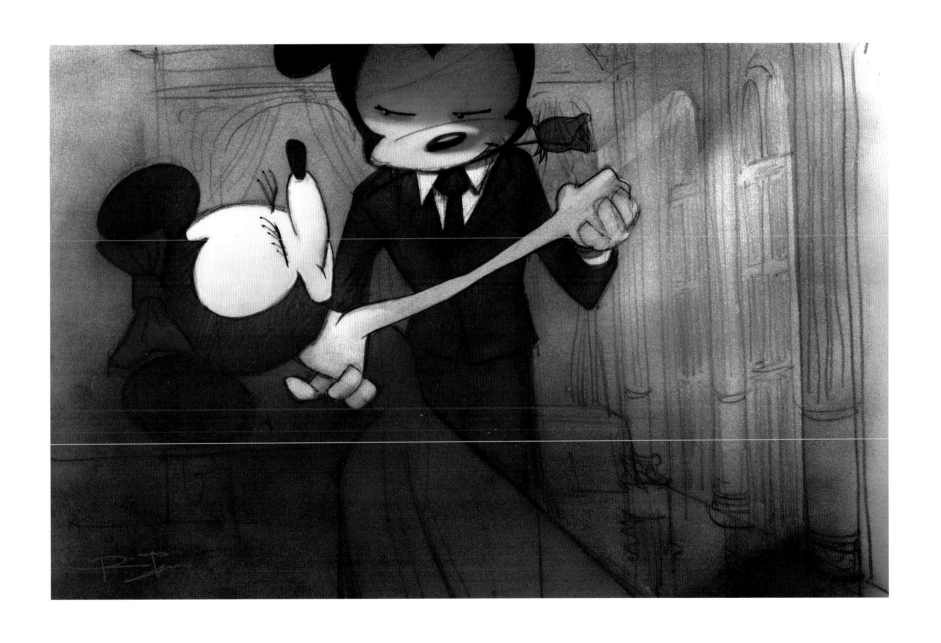

Rich Tuzon

MEDIUM: graphite and digital

• Her Humor •

"Minnie Mouse is such an icon. She is beautiful, chic, but also has this incredible sense of humor. . . .Thank you, Disney, and thank you, Minnie Mouse, for being forever my muse and making this such an incredible experience."

—Gerlan Marcel, fashion designer for Gerlan Jeans

As Exclusively told to Disney Style in the video interview, "Minnie Mouse and Gerlan: New York Fashion Week," February 15, 2013

Ben Simonsen

Medium: digital

CATHY CLARK

MEDIUM: digital

CATHY CLARK

MEDIUM: digital

• Her Humor •

"Disney adopted a very strict control over the kinds of humor that were used on his stars. Mickey, Minnie, Donald Duck, Pluto, and Goofy all had very definite character structures. Many funny gags were disallowed because Walt felt they were not within the limits of a giving personality. Such restrictions were almost unheard of in the other studios in the 1930s."

—Shamus Culhane, animator and animation director

FROM *TALKING ANIMALS AND OTHER PEOPLE: THE AUTOBIOGRAPHY OF ONE OF ANIMATION'S LEGENDARY FIGURES,* ST. MARTIN'S PRESS, 1986

ELLIE CHOI-HUEZO

MEDIUM: digital

ELLIE CHOI-HUEZO
MEDIUM: digital

• Our Muse •

"Happy birthday to the sweetest Minnie Mouse!
Thank you to Disneyland for the most amazing day!"

—Kim Kardashian, television and social media personality, from Instagram, captioning a photo of her two-year-old daughter, North, dressed as Minnie Mouse

As reported by Frederica Palmer in the article "Kim and Kanye Celebrate North's Second Birthday With A Day At Disney," Grazia magazine, June 16, 2015

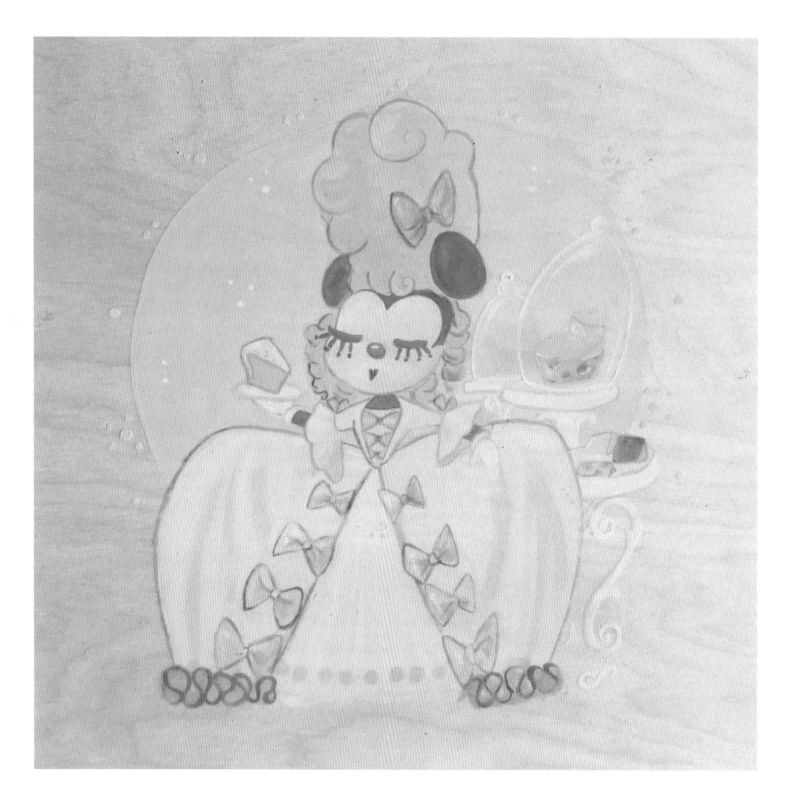

CATHY CLARK
MEDIUM: gouache on wood

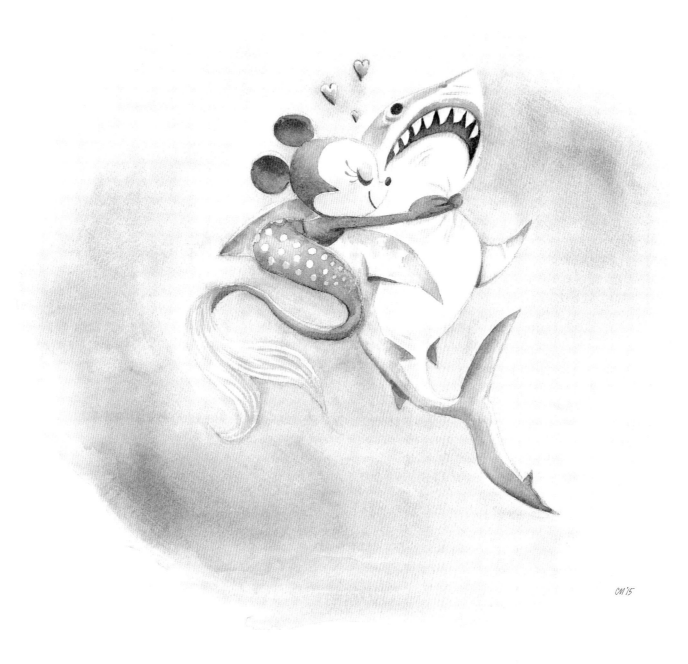

CRAIG MACKAY

Medium: watercolor on paper

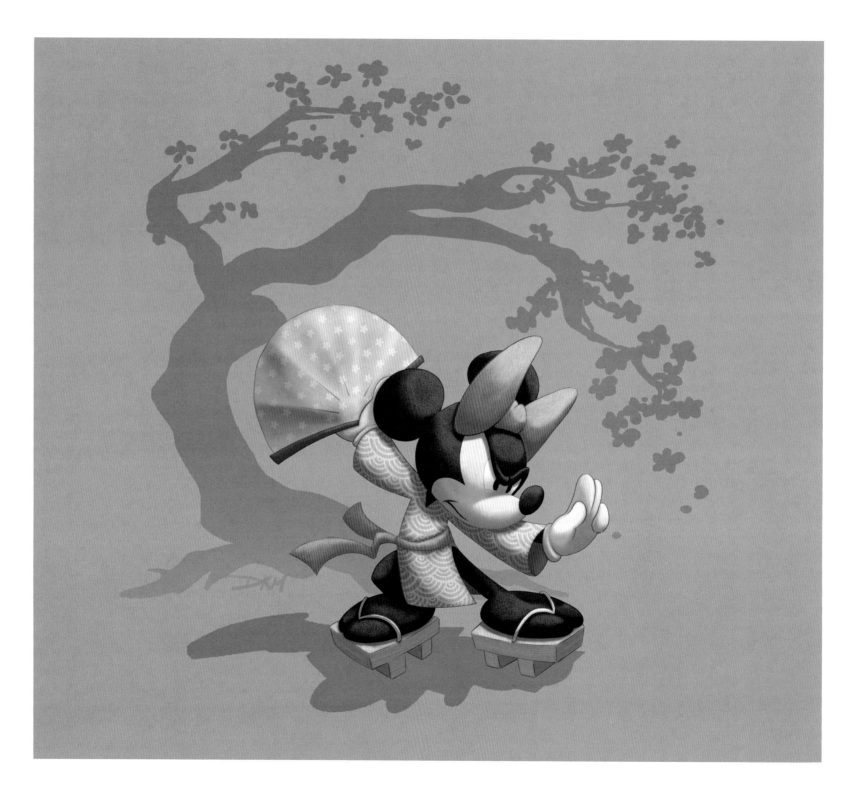

DAVE MARKOWITZ
MEDIUM: digital

GEORGE FONG
MEDIUM: digital

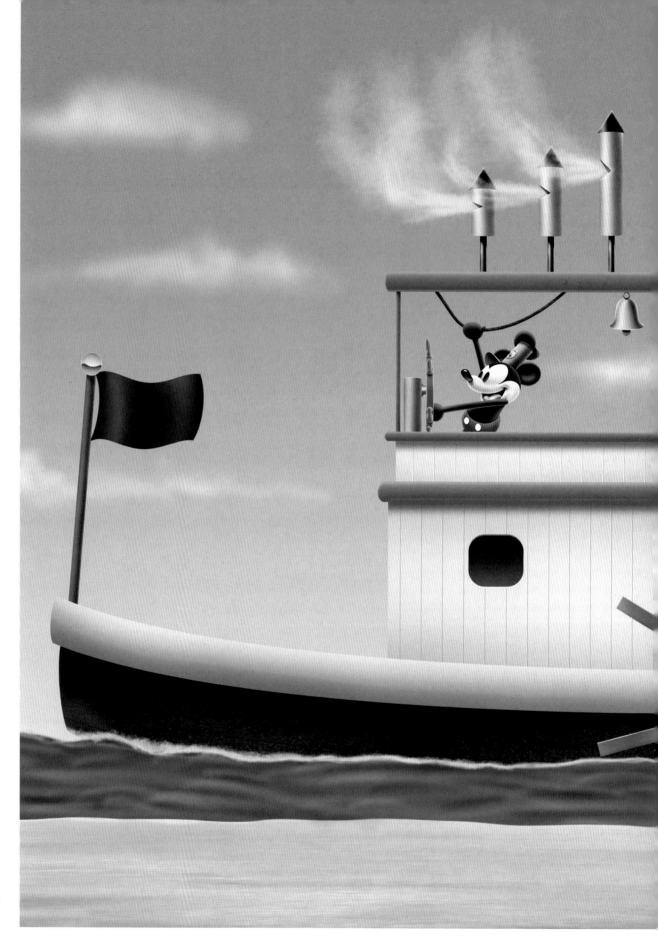

ROBERT FARRELL
MEDIUM: digital

88

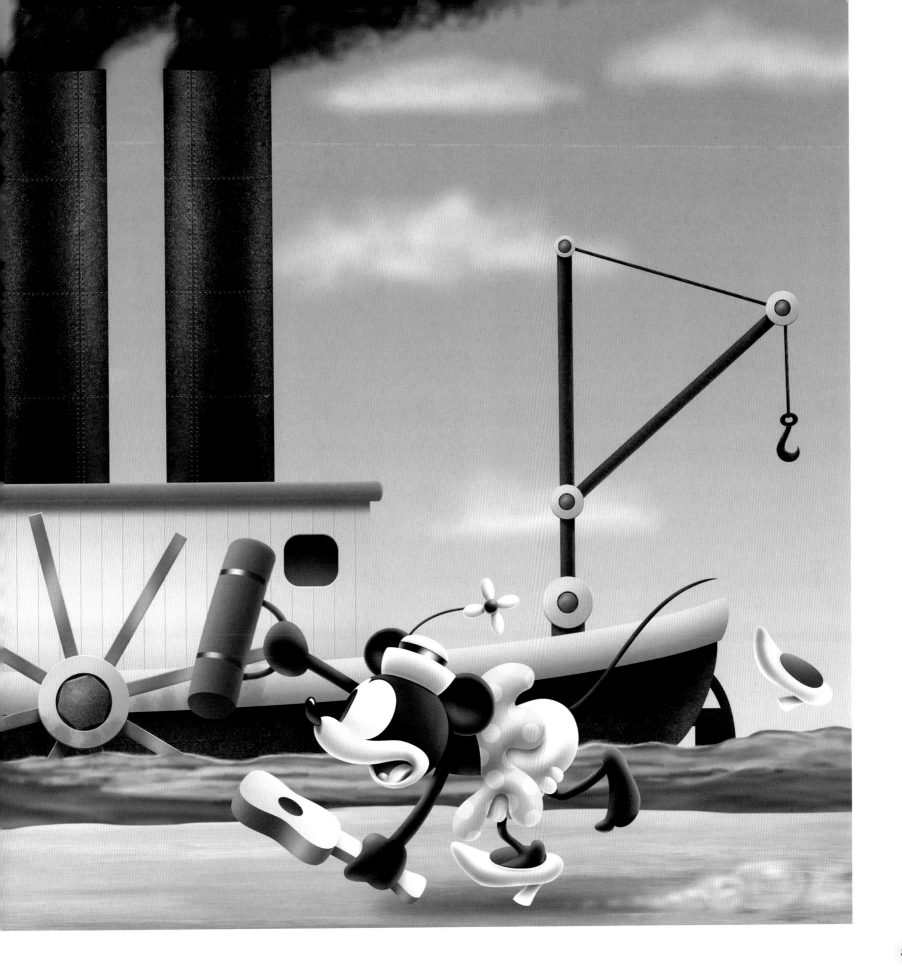

• Our Muse •

*"You are such an inspiration and your sense of style,
I mean, you've just got it. You know?
You have that 'it.' You know that Minnie Mouse,
don't you? I know you know it and it's
such a honor for me to meet you, too."*

—Sharon Osbourne, television host and media personality,
talking directly to a costume character of Minnie Mouse

As reported by Gary Buchanan in the Video "Ariana Grande Celebrates
Her 21st Birthday | Walt Disney World," Disney Parks Blog,
June 25, 2014

Miran Kim

MEDIUM: digital

• Her Polka Dots •

*"I've always loved Minnie.
I even have a Minnie-themed bathroom,
red with white polka dots. I'm not kidding!"*

—Georgia May Jagger, model, photographer, and curator of
the September 2015 London art exhibit *Minnie: Style Icon*,
a display of Minnie-inspired photographs and memorabilia

As exclusively told to Joe Stone for the article "Georgia May Jagger:
'I've Been Making Country Music With Cara And Suki!',"
Grazia magazine, April 8, 2015

NANAKO KANEMITSU
MEDIUM: digital

KITTY GRIER
MEDIUM: digital

DAVE PACHECO
MEDIUM: digital

• Her Polka Dots •

*"I don't think there is ever
a wrong time for a polka dot."*

—Marc Jacobs, fashion and accessories designer

As reported by the Disney Blog "Minnie Mouse: Style Icon,"
January 30, 2014

Gina McClurg
MEDIUM: digital

• Her Style •

"I've been raised by Mum to think that fashion should be about fun. Most of the clothes that I'm drawn towards are quite zany, so I feel like we [Minnie and I] have that in common."

—Georgia May Jagger, model, photographer, and curator of the September 2015 London art exhibit *Minnie: Style Icon*, a display of Minnie-inspired photographs and memorabilia

As exclusively told to Edwina Langley for the article "Georgia May Jagger On Her Minnie Mouse Show And The 'Terrifying' Catwalk," Grazia magazine, September 19, 2015

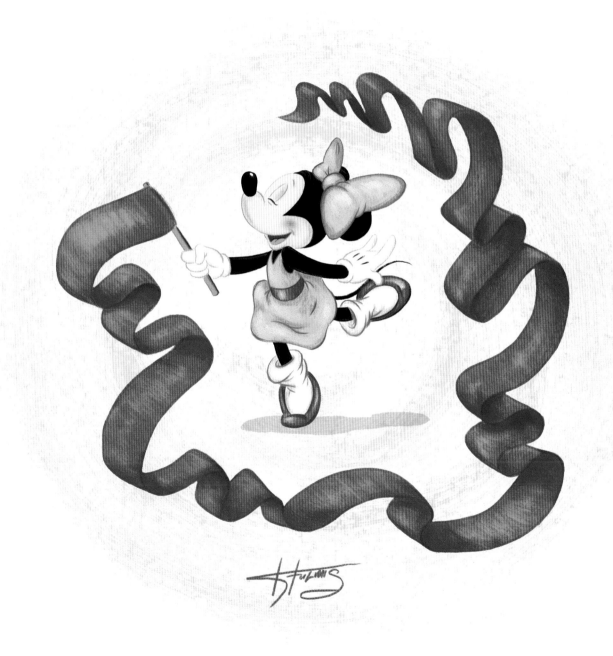

KEITH FULMIS
MEDIUM: digital

STEPHANIE LURIE

MEDIUM: digital

MARCI SENDERS

MEDIUM: pen and ink and digital

KATHRYN FERONS

MEDIUM: paper sculpture

DIANA PARK
MEDIUM: digital

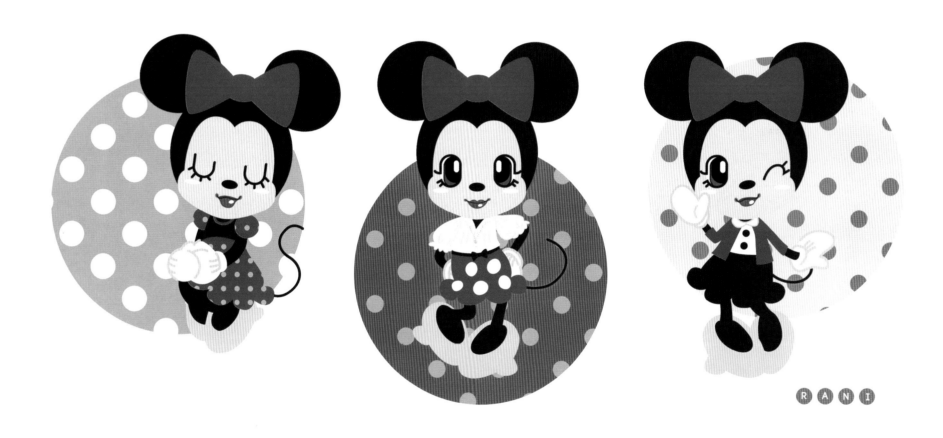

RANI CHUNG
MEDIUM: digital

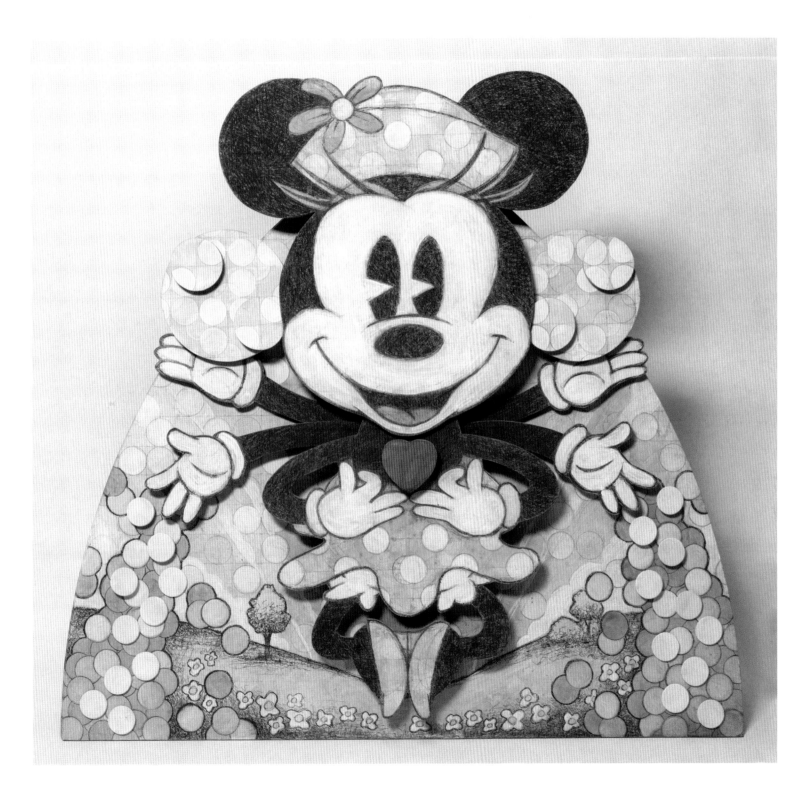

KURT HARTMAN

MEDIUM: mixed media (Gesso, acrylic, and charcoal on board)

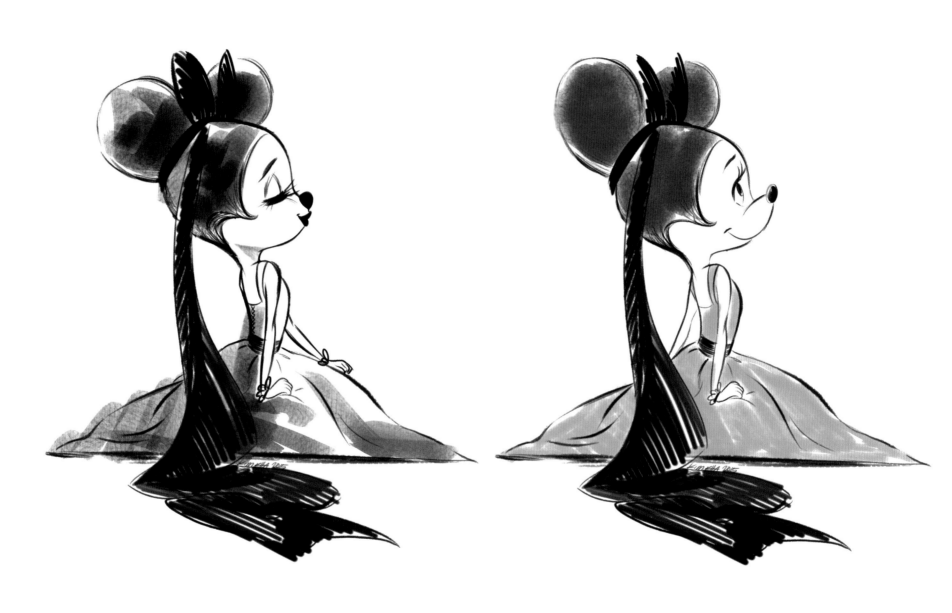

Kim Kha

MEDIUM: digital

• Her Gallery •

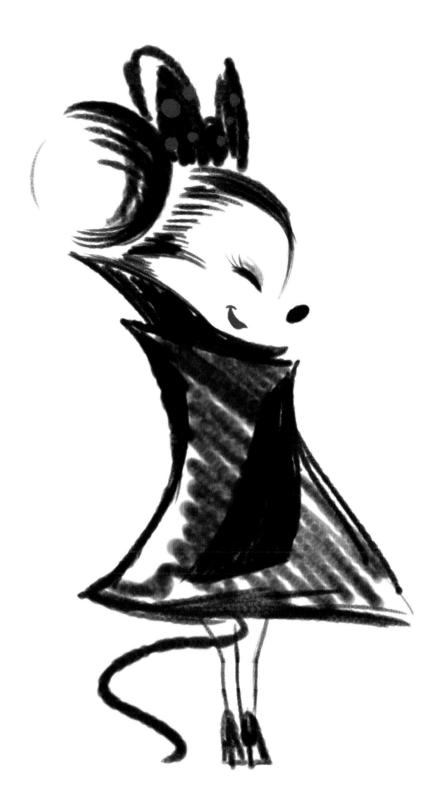

Kim Kha
MEDIUM: digital

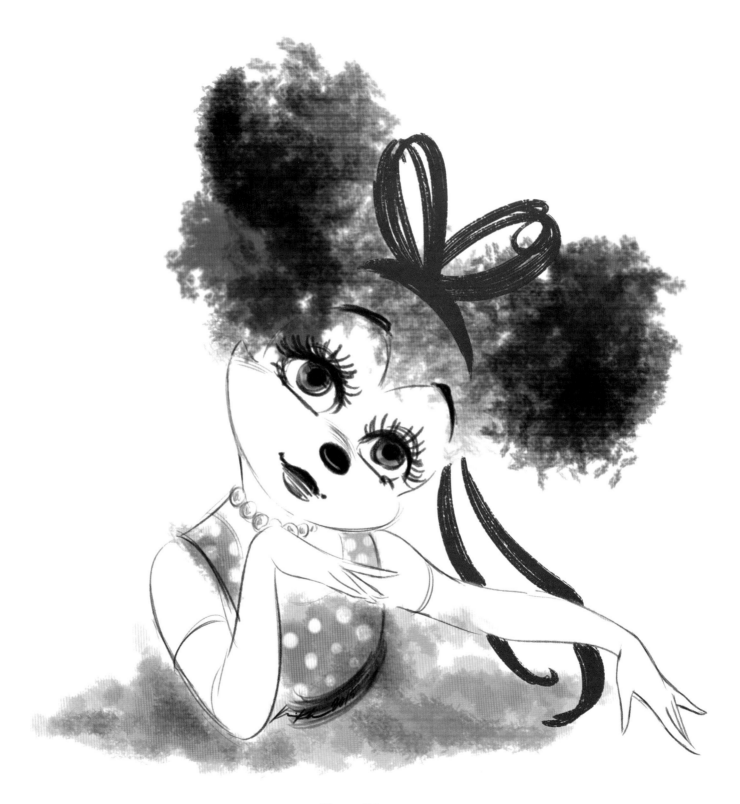

Kim Kha

MEDIUM: digital

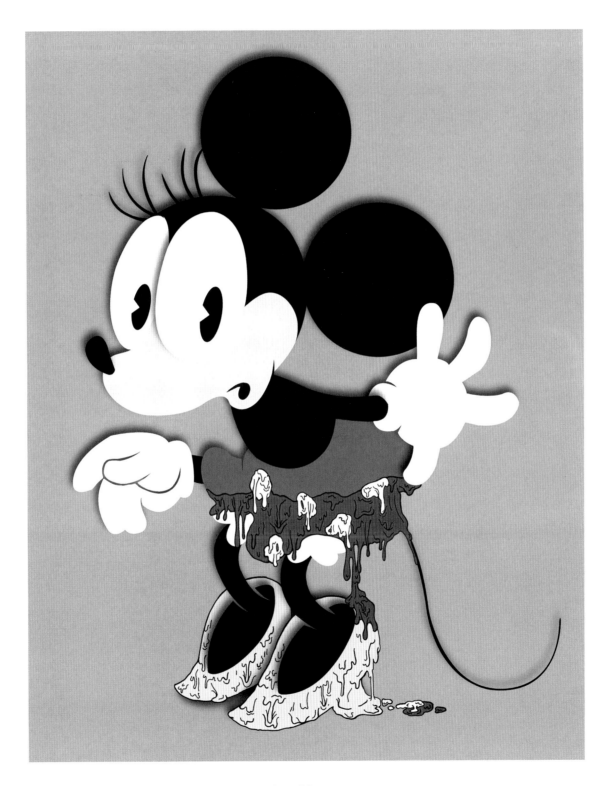

MARK. J. MONTERROSO
MEDIUM: digital

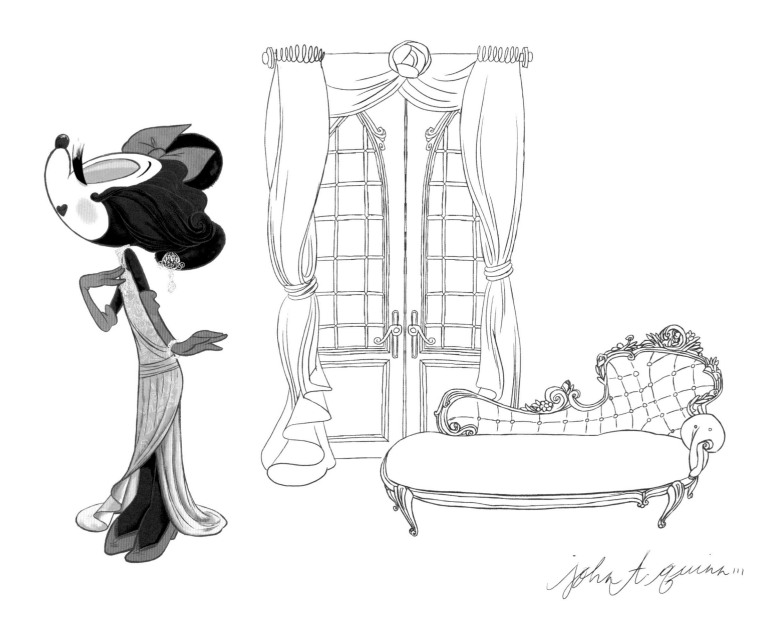

John Quinn

Medium: digital

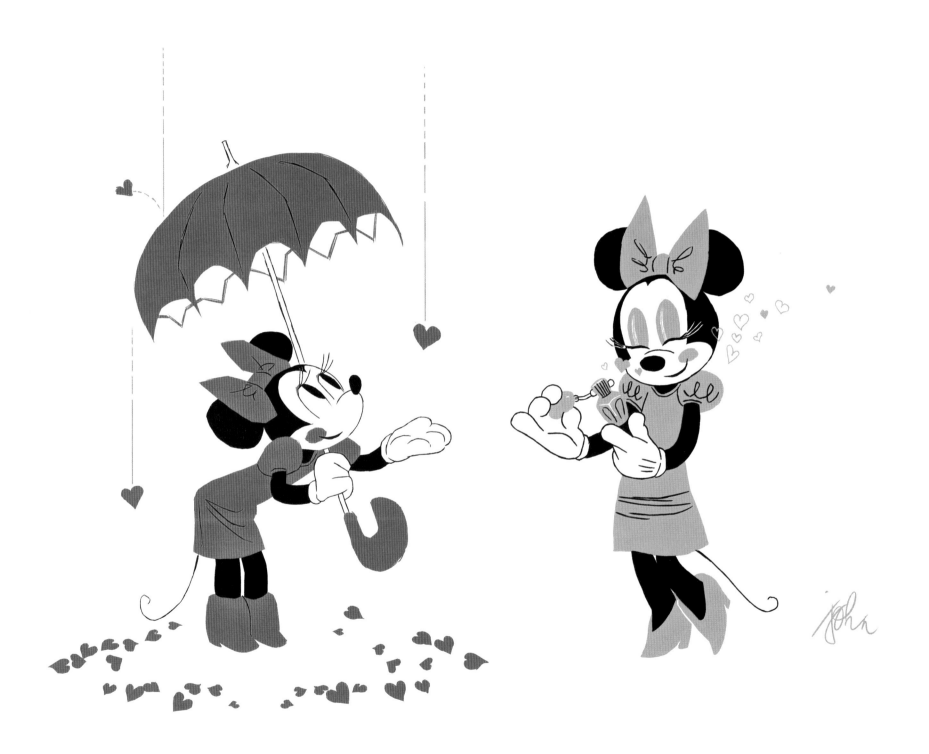

John Quinn
MEDIUM: digital

Vin Seong

MEDIUM: digital

TIFFANY QUON
MEDIUM: digital

MARIA DE LA CRUZ

MEDIUM: digital

Winnie Kang
MEDIUM: digital

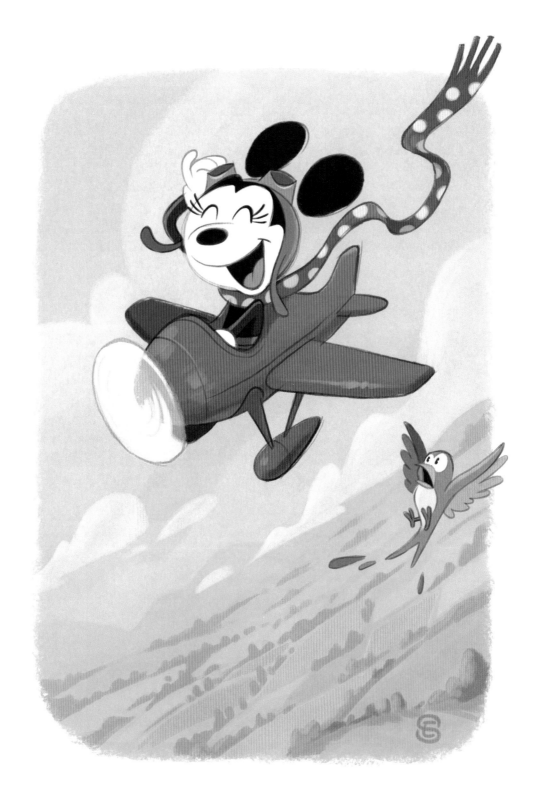

Emil Salim

Medium: digital

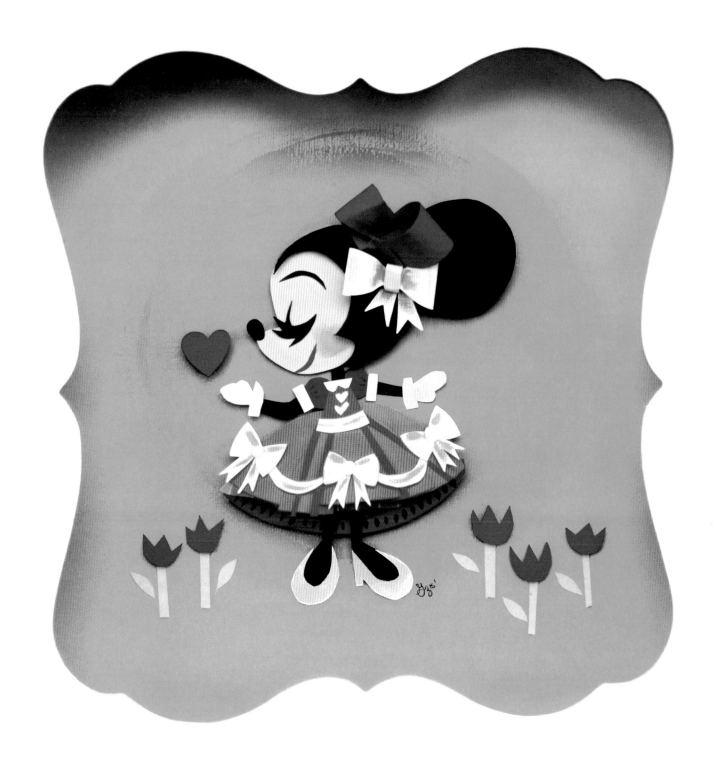

GABRIELA ZAPATA

MEDIUM: cardstock paper and paint

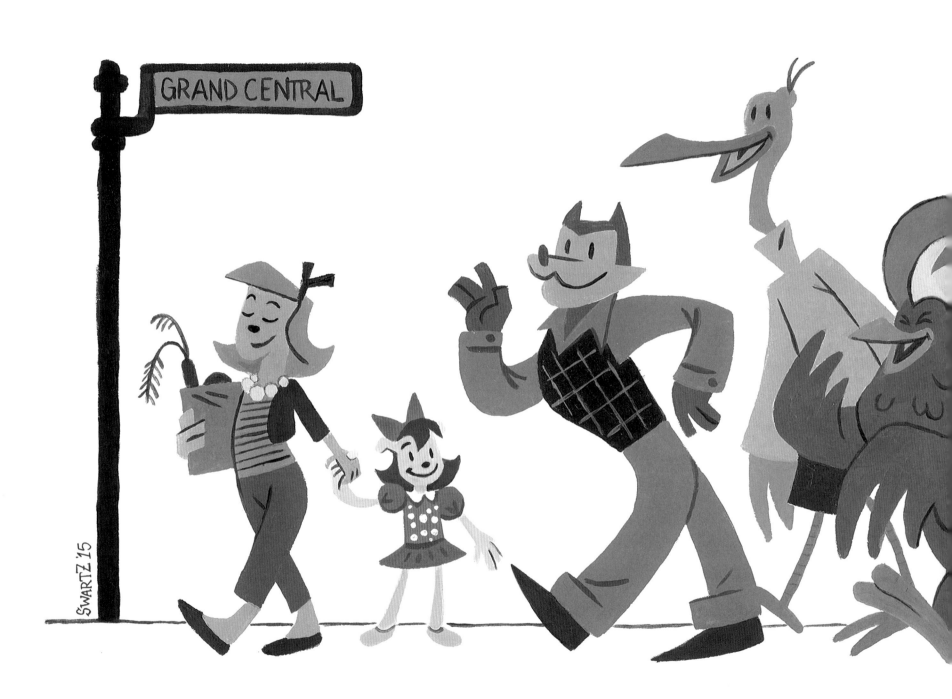

SWARTZ '15

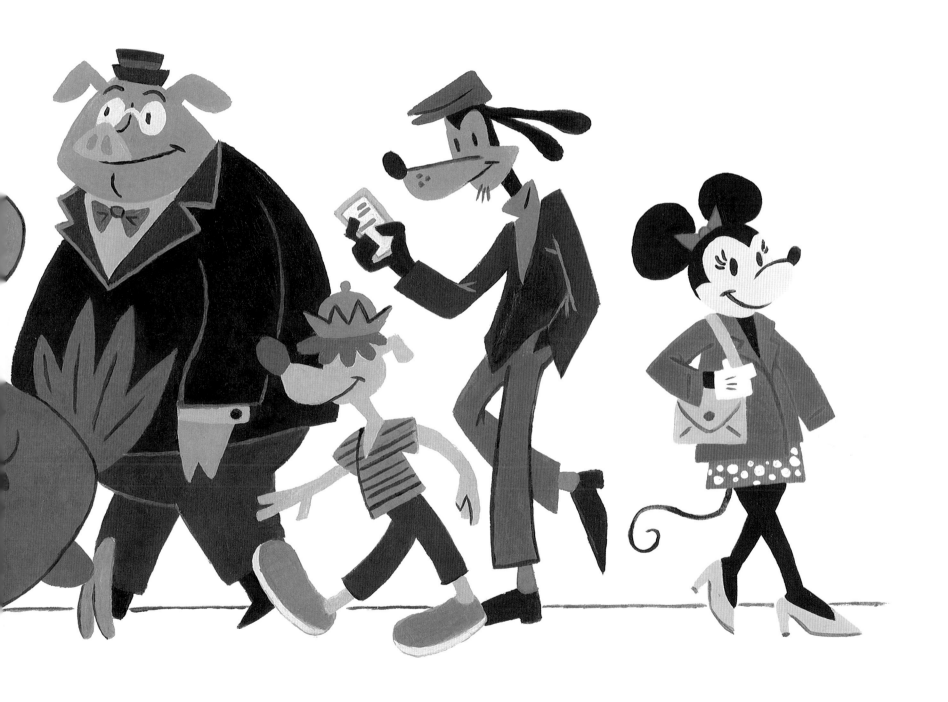

MATT SWARTZ

MEDIUM: acrylic

• Her Style •

"Surpassing trends, Minnie Mouse's iconic silhouette, signature bows, and polka dots always remain in style— which is why she is as relevant today as the day she first appeared on the fashion scene."

—Marc Low, vice president of fashion and home, The Walt Disney Company, Europe, Middle East, and Africa, on collaborating with fashion designers for Minnie-themed clothing at London Fashion Week in September 2012

As reported by Biana London for Mailonline "Minnie Mouse, fashion muse! Disney star announces her own London Fashion Week show with outfits by designers Giles, Deacon, Lulu Guinness and Richard Nicoll," August 17, 2012

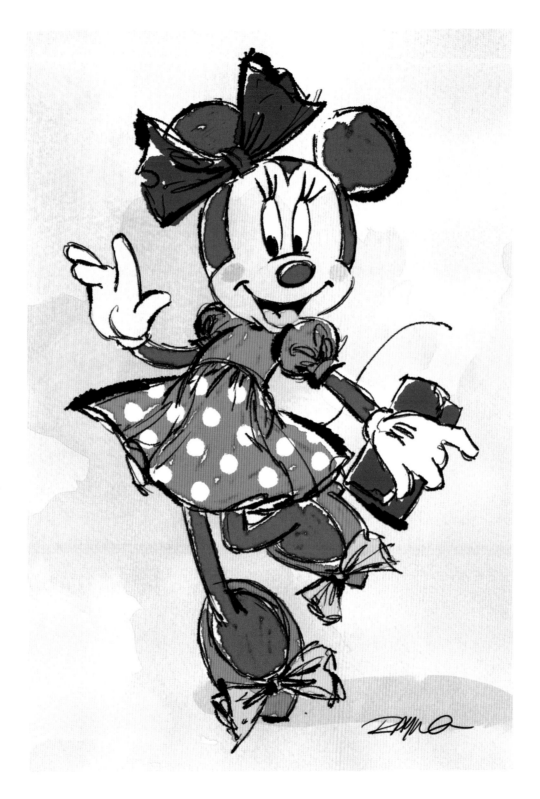

Kim Raymond

MEDIUM: digital line and watercolor

• Her Style •

"Minnie is perhaps the one style icon that girls of all ages can relate to. Her polka dots and bows are playful, yet sophisticated, and embody a confident femininity that's truly timeless."

—Lilliana Vazquez, stylist and fashion expert

As reported by the Disney Blog "Minnie Mouse: Style Icon," January 30, 2014

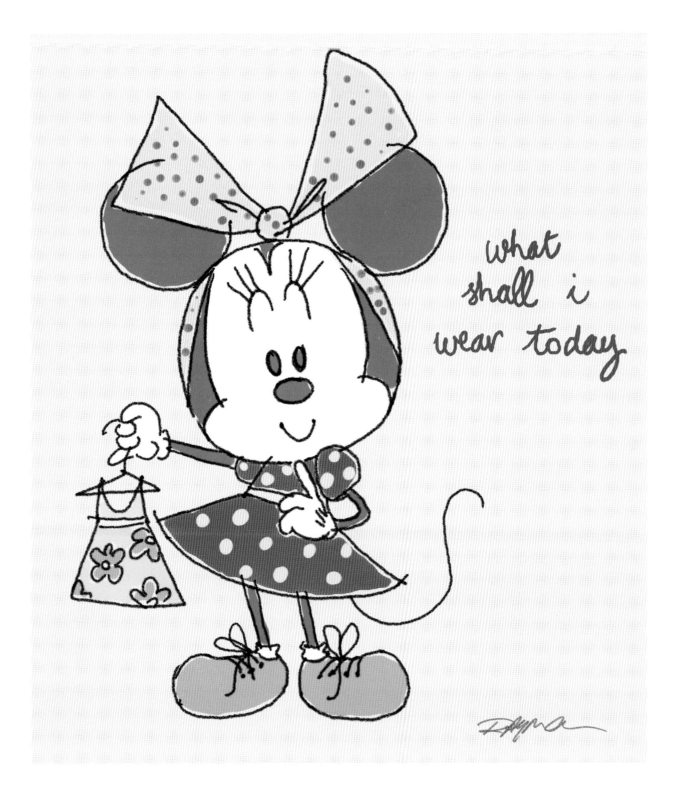

what shall i wear today

Kim Raymond
MEDIUM: digital line and watercolor

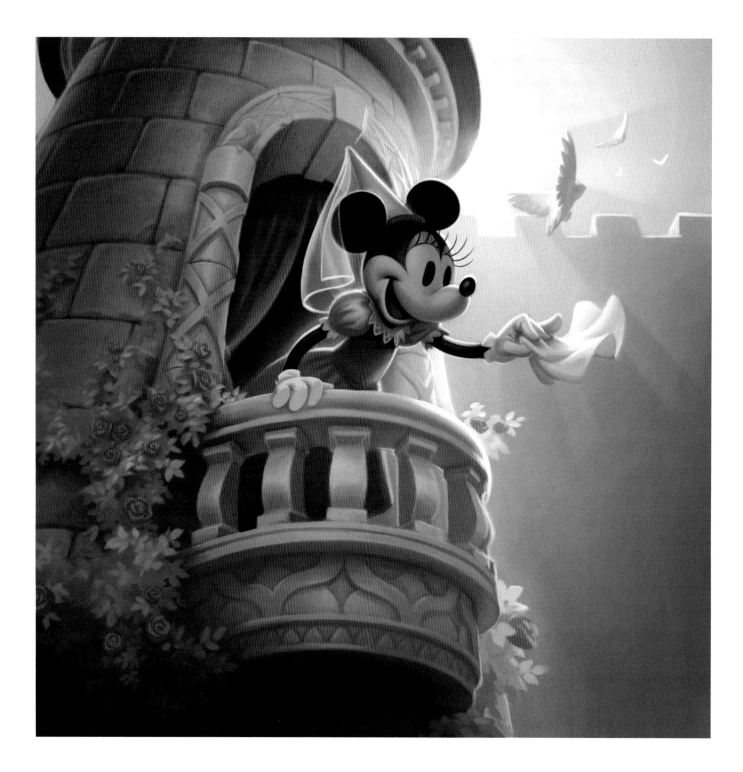

Kevin Keele

MEDIUM: digital

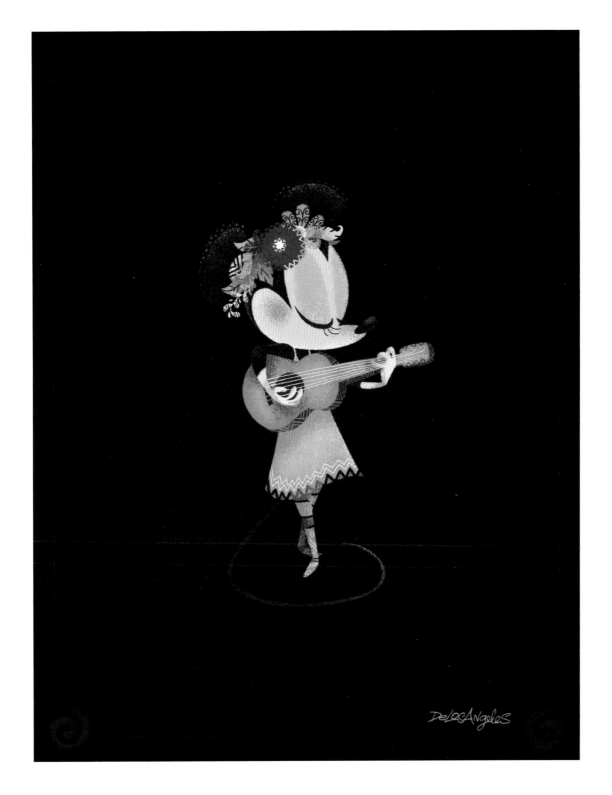

RICKY DE LOS ANGELES

MEDIUM: digital

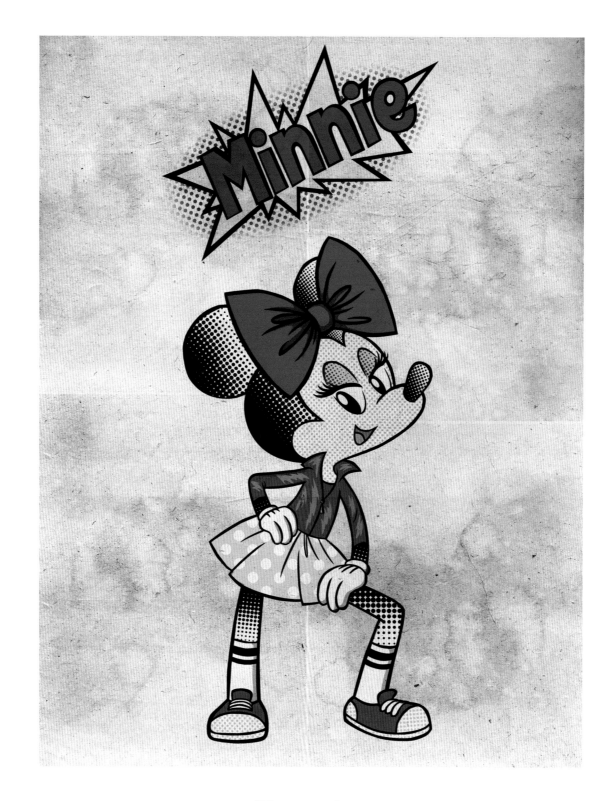

Miran Kim

MEDIUM: digital

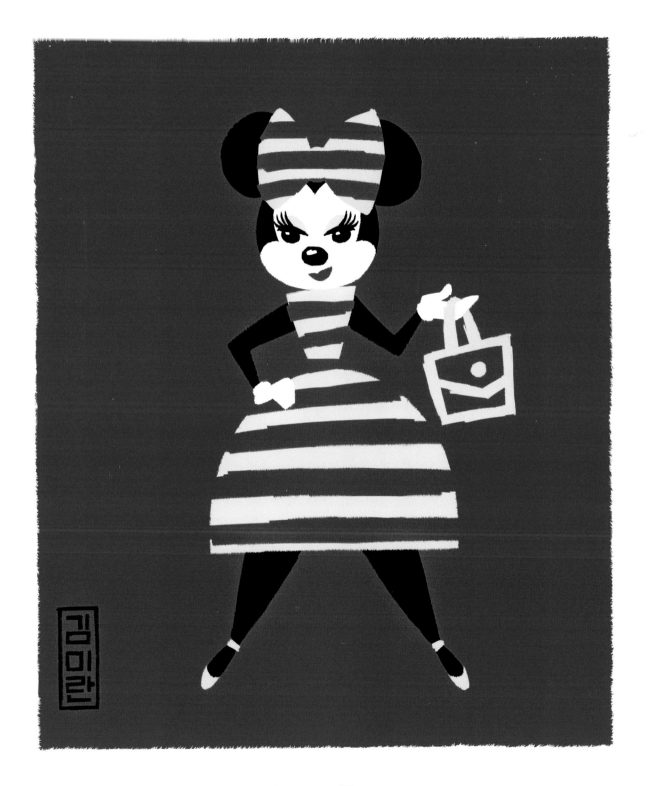

Miran Kim
MEDIUM: digital

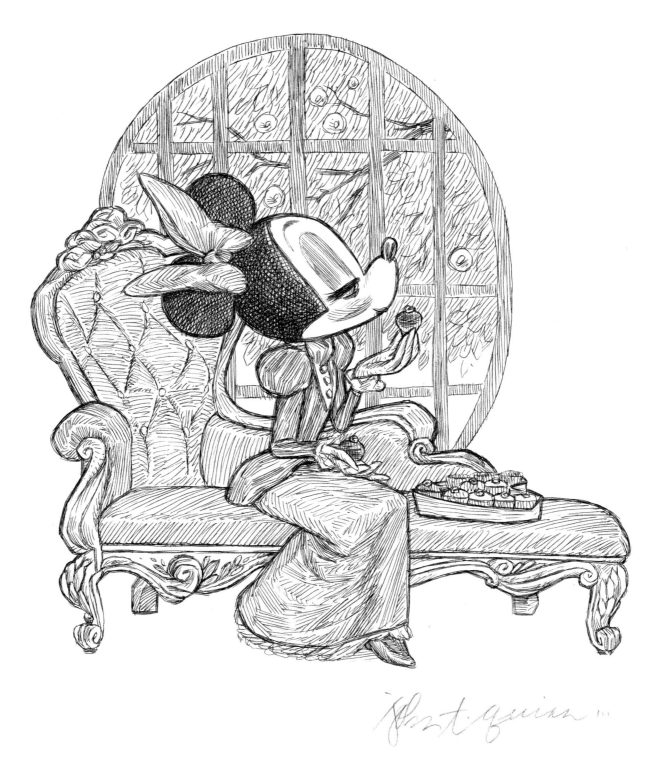

John Quinn

MEDIUM: pen and ink

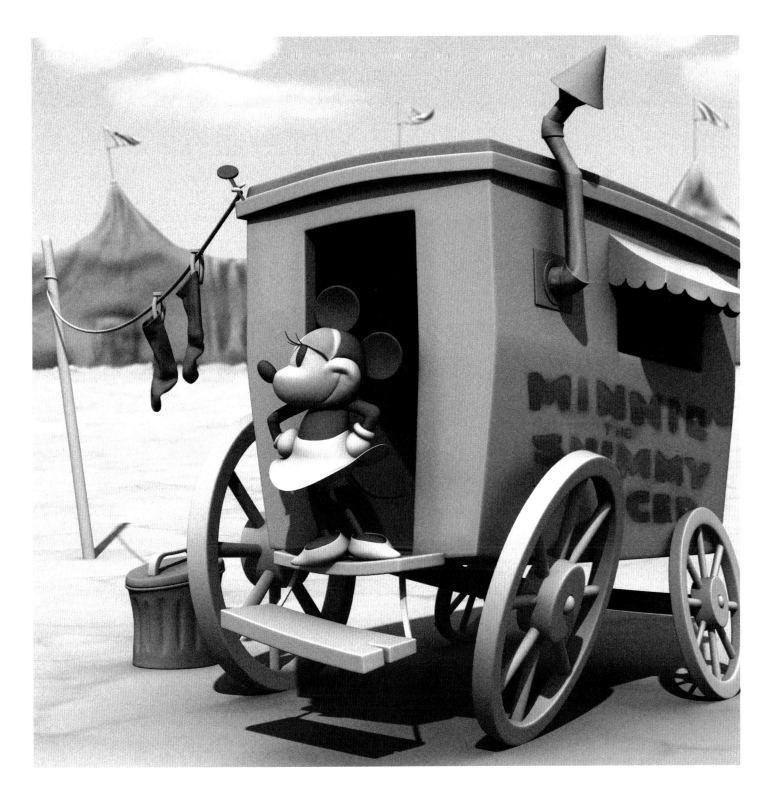

LEO OLIVETO
MEDIUM: digital 3-D

• Her Name •

*"Every dashing man needs an ingenue for whom to fight.
Ub [Iwerks] created a female mouse to be Mickey's counterpart.
The name of the female lead required less introspection or deep thought.
Walt named her Minnie Mouse in honor of the benefactor of
the Laugh-O-grams Studio: Minnie Cowles."*

—Leslie Iwerks, independent film writer, producer, director,
and artist, and John Kenworthy, author

FROM THE HAND BEHIND THE MOUSE: AN INTIMATE BIOGRAPHY OF UB IWERKS,
THE MAN WALT DISNEY CALLED "THE GREATEST ANIMATOR IN THE WORLD,"
DISNEY EDITIONS, 2001

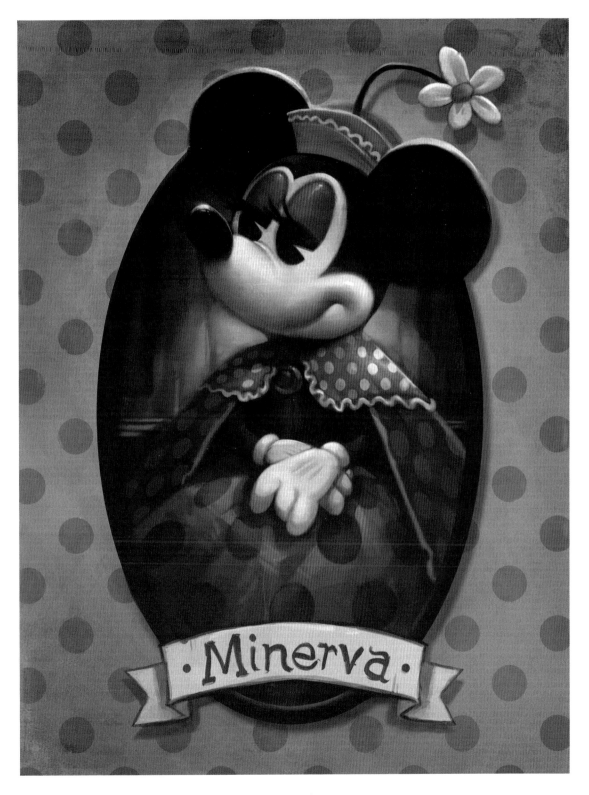

RYAN WOOD

MEDIUM: digital

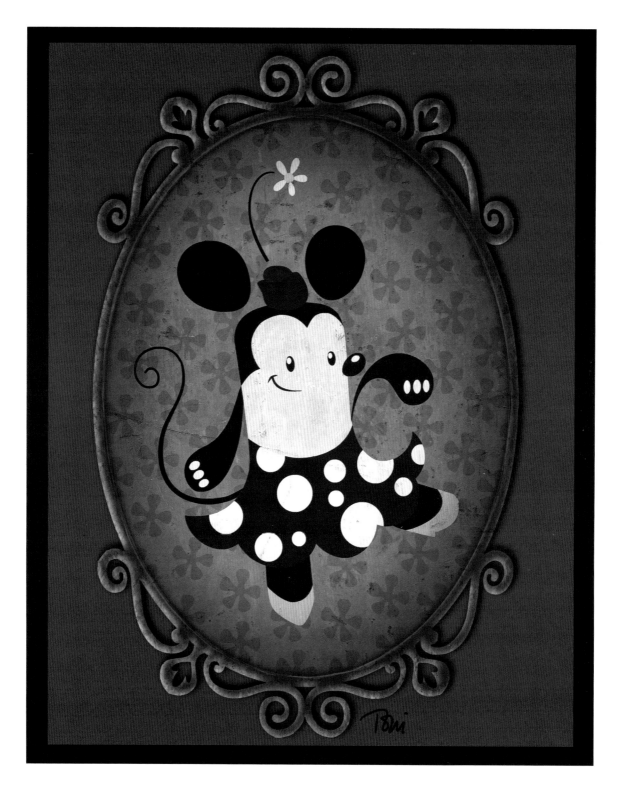

Toni Tysen

Medium: digital

LEO OLIVETO

MEDIUM: digital 3-D

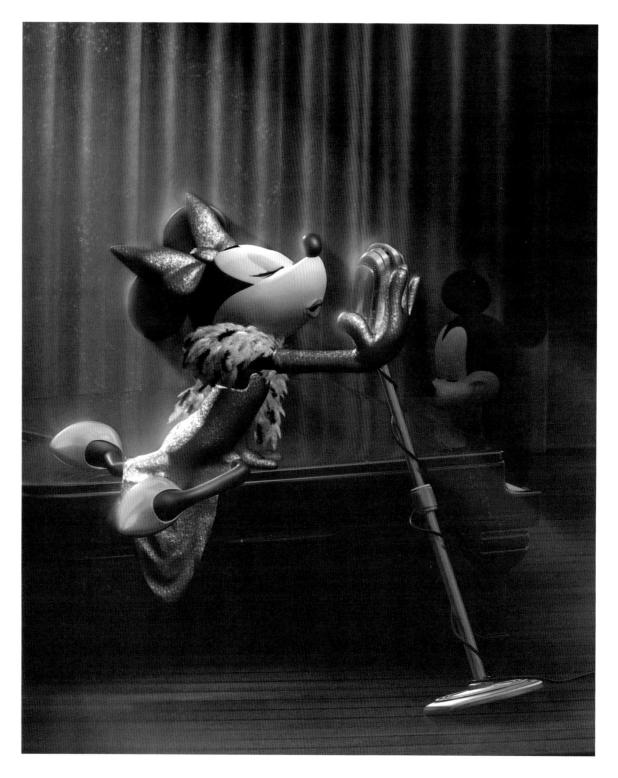

LEO OLIVETO
MEDIUM: digital 3-D

Kim Raymond

MEDIUM: chalk pastel with digital finishing

JOHN QUINN
MEDIUM: digital

John Quinn
MEDIUM: digital

STEVE THOMPSON
MEDIUM: digital

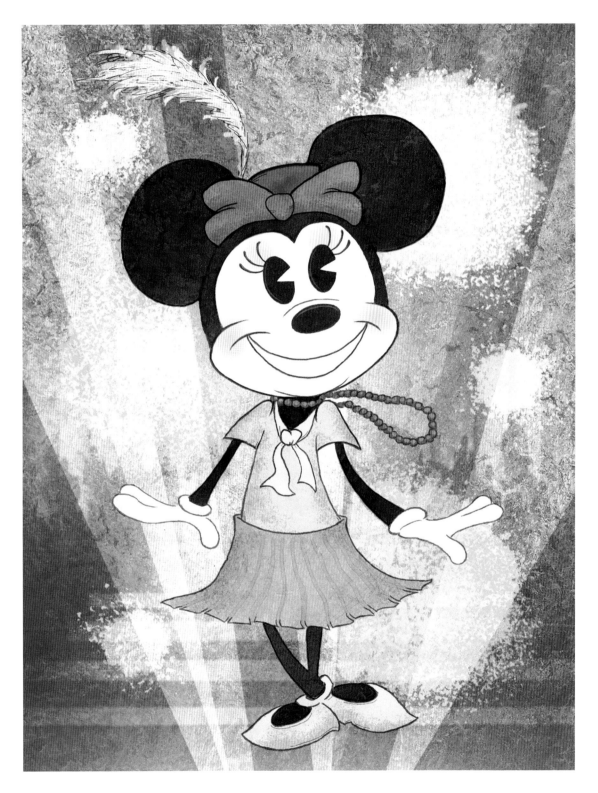

PHIL CAMINITI
MEDIUM: digital

ANDREW TAYLOR

MEDIUM: digital

ANDREW TAYLOR
MEDIUM: digital

ANDREW TAYLOR

MEDIUM: digital

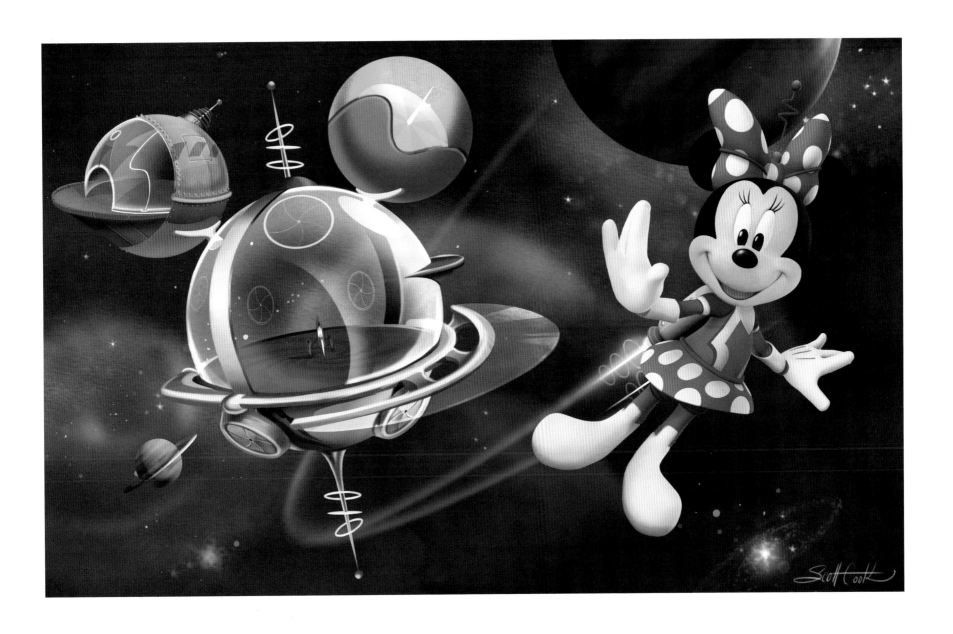

SCOTT T. COOK

MEDIUM: digital

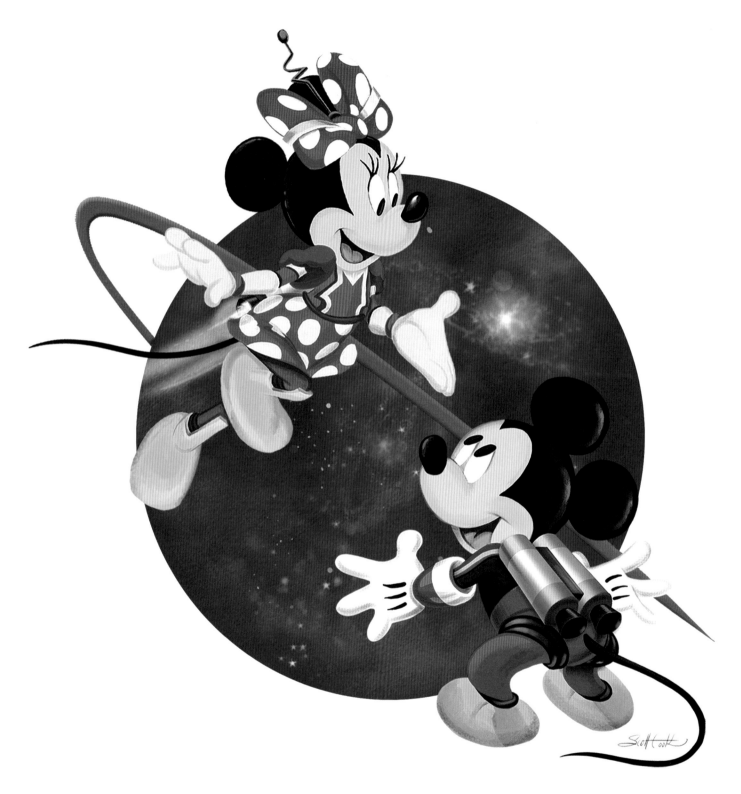

SCOTT T. COOK

MEDIUM: digital

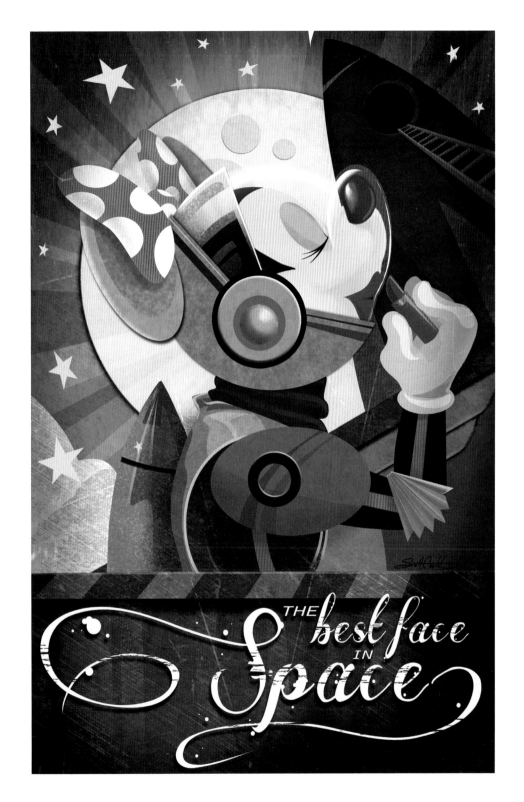

SCOTT T. COOK
MEDIUM: digital

• Her Independence •

Mickey: (chuckling) Howdy, stranger. Y'all coolin' off?
Reckon I can help any?

Minnie: (insulted) On your way, cowboy.
I can take care of myself.

—1934 dialogue from the Mickey Mouse short *Two-Gun Mickey*,
after cowgirl Minnie is thrown into a water puddle
by her spooked horses

SHORT DIRECTED BY BEN SHARPSTEEN

Toni Tysen

Medium: digital

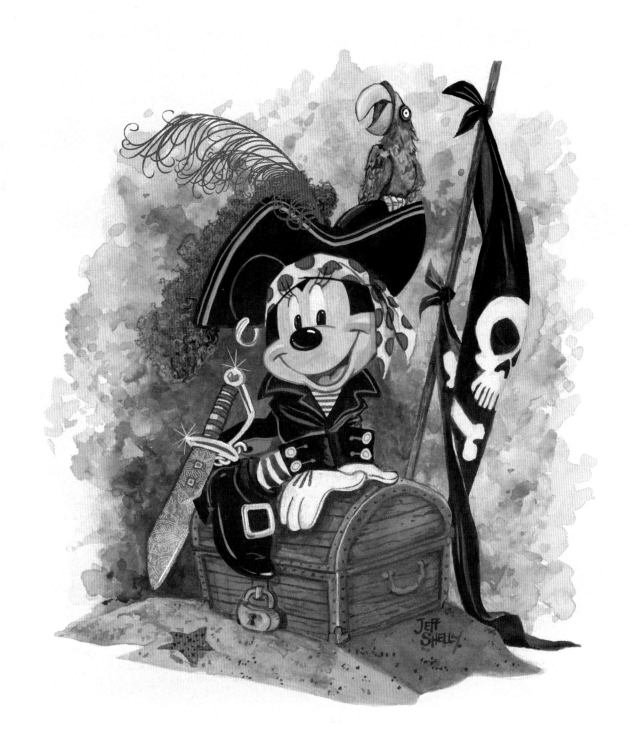

JEFF SHELLY

MEDIUM: watercolor and digital

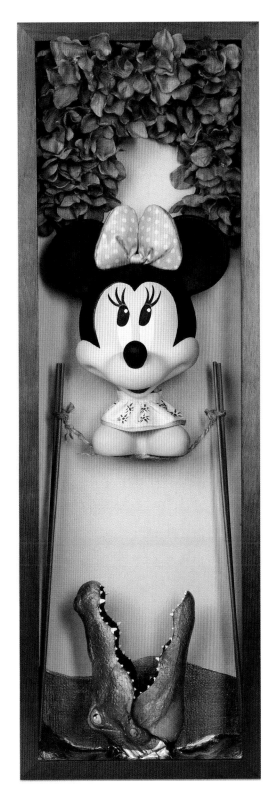

ROBERT FARRELL

MEDIUM: mixed media (acrylic, modeling clay, fabric, and shadow box)

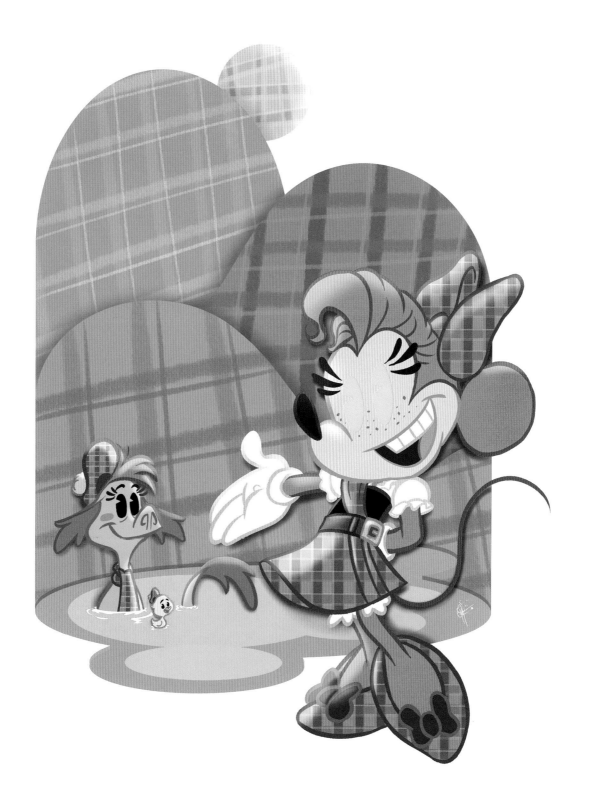

JEFFREY THOMAS
MEDIUM: digital

Miran Kim

MEDIUM: digital

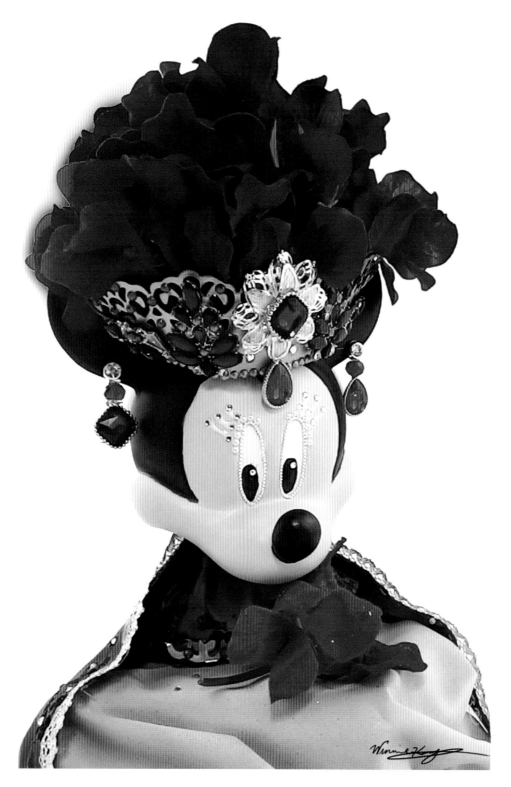

Winnie Kang

Medium: vinyl, fabric, jewels, and acrylic

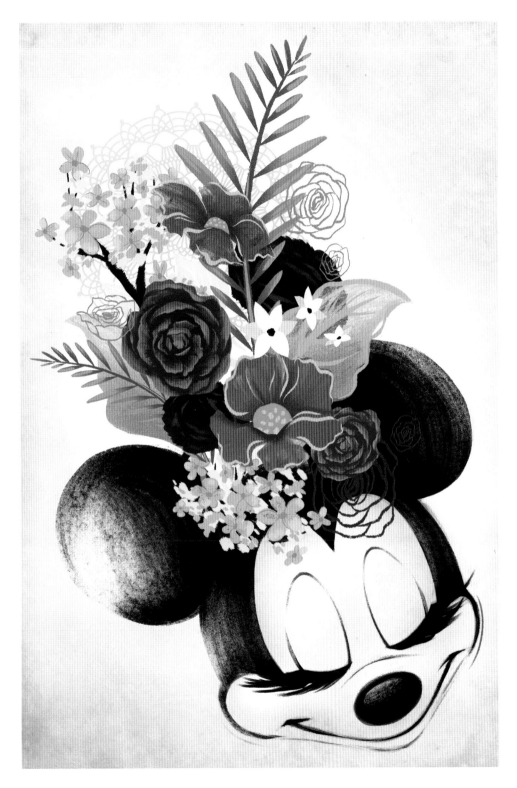

STACEY AOYAMA

MEDIUM: digital

• Her Song •

I'm the guy they call little Mickey Mouse / Got a sweetie a sweetie down in the chicken house / Neither fat nor skinny / She's the horse's whinny / She's my little Minnie Mouse!

When it's feedin' time for the animals / And they howl and growl like the cannibals / I just turn my heel to the henhouse steal / And you'll hear me sing this song

Oh, the old tomcat with the meow, meow, meow! / Ol' hound dog with the bow-wow-wow! / The crow's caw-caw! / And the mule's hee-haw! / Gosh what a racket like an ol' buzz saw! / I have listened to the cuckoo cuke his coo-coo! / And I've heard the rooster cock his doodle doo-oo / With the cows and the chickens / They all sound like the dickens when I hear my little Minnie's Yoo Hoo!

—1929 song lyrics from "Minnie's Yoo Hoo," (first verse and chorus)

WORDS BY WALT DISNEY AND CARL STALLING

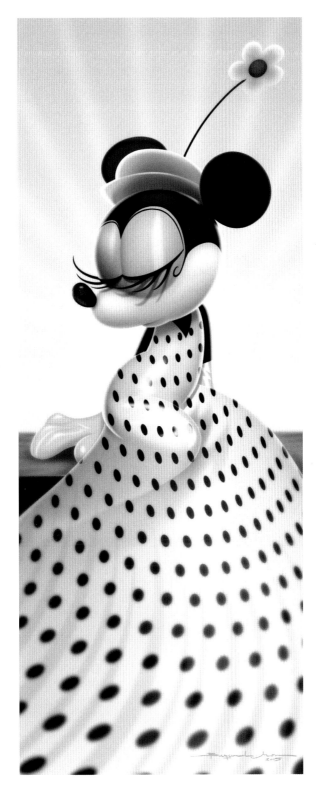

BRYAN MON
MEDIUM: digital

• Her Dresses •

*"It was a great challenge and responsibility to do.
I just wanted her to shine. . . . I wanted to give her a crown
in red, and the dress in blue, (a signature) for Lanvin."*

—Alber Elbaz, fashion designer, on creating
a runway dress for Minnie Mouse

As reported by News.Com.Au in the article
"minnie mouse gets new lanvin look at paris event,"
March 24, 2013

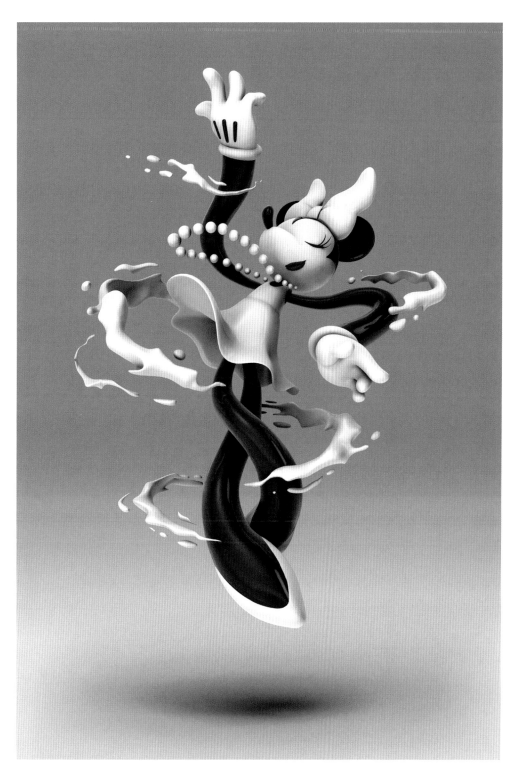

Anthony Mai

Medium: digital 3-D

• Her Dresses •

"I wanted to come home to Florida and do something that I always did as a kid for my birthday, so I got dressed up in a huge, massive Minnie Mouse-inspired fifties kind of big dress and came here and wanted to be a kid for a little while."

—Ariana Grande, singer and actress

As reported by Gary Buchanan in the Video "Ariana Grande Celebrates Her 21ST Birthday | Walt Disney World," Disney Parks Blog, June 25, 2014

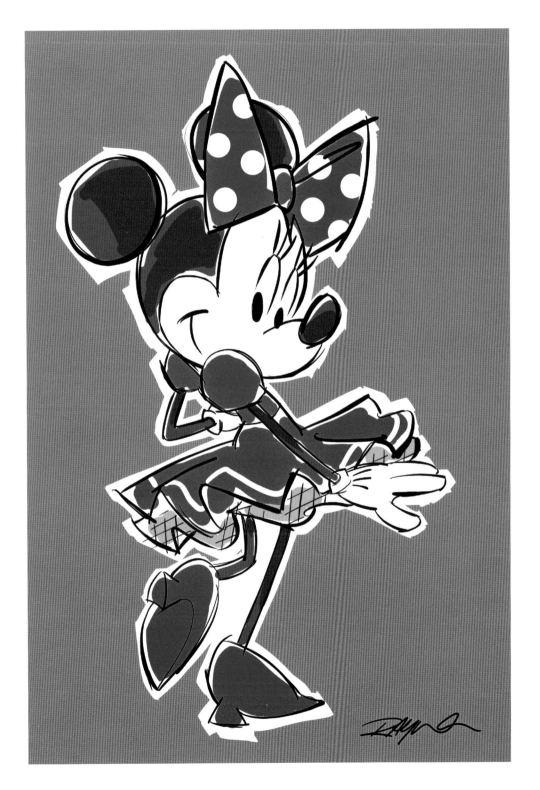

Kim Raymond

Medium: digital line and watercolor

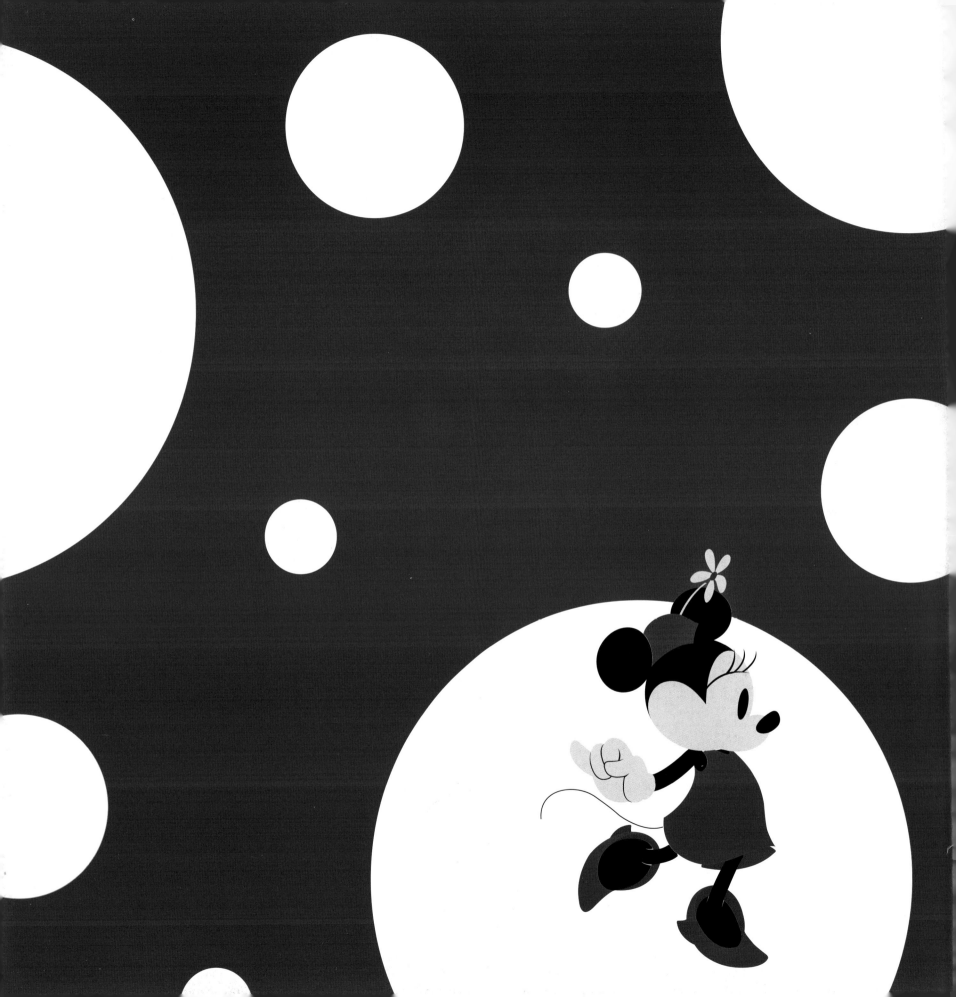